BLACK AMERICA SERIES

ALACHUA COUNTY
FLORIDA

ON THE FRONT COVER: Locked in brotherhood, these Men of Worth were committed to assist with community challenges. Pictured second from left in the first row is Abram Carnes. On the left in the second row is Rev. Charlie Louis Brown, an Archer activist serving in several capacities. (Courtesy of Theresa Brown Robinson.)

ON THE BACK COVER: This image was taken at Archer Negro High School in 1951 following a commencement ceremony. Archer was a small community, united in strength. Pictured from left to right are (first row) Dock Alexander, Marie Irons, Ida Rowe, Mittie Clayton, Tom Robinson Jr., Brady Sams, Perry McKinley, Revea Rollins, Ethel Nattiel; (second row) Lucille McGinnis, Leatha Williams, John Henry Witherspoon, Hence Rowe, Richard Nattiel, Elmo Spann, Rev. S. H. Hawkins, Ura Robinson, and Jacob Dotson. (Courtesy of Doris Jones.)

BLACK AMERICA SERIES

ALACHUA COUNTY
FLORIDA

Lizzie PRB Jenkins

ARCADIA
PUBLISHING

Published by Arcadia Publishing
Charleston SC, Chicago IL, Portsmouth NH, San Francisco CA

Printed in the United States of America

Library of Congress Catalog Card Number: 2006932626

For all general information contact Arcadia Publishing at:
Telephone 843-853-2070
Fax 843-853-0044
E-mail sales@arcadiapublishing.com
For customer service and orders:
Toll-Free 1-888-313-2665

Visit us on the Internet at www.arcadiapublishing.com

This book is dedicated to all of our grandmothers, grandfathers, and other ancestors who made immeasurable contributions to our culture. God graced their fearless efforts, hardships, and rights of passage.

This book is also dedicated to my ancestral lineage: Robinson, Brown, Sams, McIntyre, Cotman, Coleman, Davis, and Bowman, living and deceased, who planted the historic seeds many years ago.

Today, January 30, 2007, on my father's birthday, I dedicate this book to my parents, Ura and Theresa Robinson, my long-standing heroes. As a child, they encouraged reading and listening in the home. They started reading to me at birth, October 25, 1938, up until the time I started to talk and learned to read comprehensively and independently, which motivated a desire to read every book within reach, including the family Bible.

My parents told me, "Reading is talk written down." I started writing down conversations I heard in the home, which increased my vocabulary, prompting me to write short sentences, longer sentences, short paragraphs, longer paragraphs, short stories, and longer stories, and today, I write books. There was no stopping me when I started creating characters illustrating my writing.

Influential family values instilled early inspired me to become an educator, a historian, a researcher, and a writer; all in acumen dedicated to Juliann Sans, who wanted—even more than her freedom—the opportunity to read and the right to vote, both of which she was denied. Writing acumen went from fantasy to reality as I listened to family stories told many times over.

Character-building skills started at home on the farm, supplemented with real-life skills in a farm setting. After a hard day's work on the farm, bonding at suppertime, kitchen cleanup, education reinforcement, life-skills outlined, and work ethics in review, each day ended with family prayer while sitting around a potbellied heater.

After a 33-year teaching career, I continue to write "my story" on the same farm I grew up on as a child.

CONTENTS

ACKNOWLEDGMENTS

Gratitude is conveyed to friends, relatives, and colleagues who contributed to the sacred moments in this Black America Series.

First, thanks to my father, Ura Robinson, for giving me a foundation based on common sense, and to my mother, Theresa Brown Robinson, whose passion for preserving family photographs and documenting the black history of Archer (a predominantly African American city in Alachua County) made it possible for me to share the wealth of information she collected and preserved over the years. Her belief is stated as such, "For unless we remember and preserve history, future generations will never understand."

Thanks to John Jenkins Sr., Nathaniel and Rebecca Hall, Tom and Dona Coward, Andrew and Catherine Mickle, Earline Harper, Cleve and Barbara Sharpe, Richard and Mary Brown, Susie White, Magnolia Jackson, Charlie and Alberta Nelson, Arthur Shell, Thelma McKnight, Robert Ayer Jr., Jim Powell, Carrie and Atkins Warren, Edna Brown, Burnice Gaskin, Mabel Vernon, Oliver and Katie Jones, Bonnie Burgess, Roamules Kyler, Willie Mayberry, Arthur and Liz Miles, Ernestine Walker, Julia Harper, Martha Braker Bennett, George Pinkney Jr., Wilma Simmons, Joe Louis Clark, Arthur Jones, Betty Bennett, George Pinkney III, H. Ron and Juanita Nelson, Leonard R. Kearse, Karen Sams, Bobby Nelson, Earl and Jackie Wilson, Bennie Jean Nelson Edwards, Gloria Randolph, Lois Goston, Jearl Miles Clark, Amos Smith, Florida Memorial University, Bethune Cookman College, the NAACP Web site, Ceola Palmore Watkins, Buddy Irby, Mattie Williams, C. Ann Scott, Rosemary Christy, John R. Cotman, Smathers Library, Alachua County court records, Mildred Dewberry Oliver, Oretta Williams Duncan, Joel Buchanan, Namia Brown, Eartha Miles Hutchinson, Ernestine Jefferson, Charles Goston, Thelma Welch, LaKay Banks, Leroy and Rosa Robinson, Rosa Lee Webb, the Black Student Union at Santa Fe Community College, *Black College Monthly*, Alachua County Library District, Matheson Historical Society, the Morris Agency, *Alachua Post*, *Gainesville* magazine, *Gainesville Sun*, TV20, the University of Florida Senate, *Independent Alligator*, the Pan Hellenic Council Web site, the Academy of Achievement, the Gainesville Police Department, A Vintage Book, and www.rootsweb.com.

INTRODUCTION

History is a mirror that people use to reflect on their cultural development and sustainable improvements. The brave souls who endured slavery undeniably envisioned social adjustments, economical development, and educational empowerment for their people.

The once enslaved contributed much free labor to build Alachua County. These early settlers succeeded in spite of bigotry and vulnerability. Many were the masterminds behind some of the initiatives that produced major inventions.

Slave owners looked to them for common-sense proposals to make work less taxing for all, never hesitating to patent or claim ownership of an invention derived from a slave's idea, rather than credit the real inventor's place in black history. However, because these slaves were brought to America with no trade, no custom, no legacy, and no perspective on a system that worked against them, they remained humble. These men and women had to learn a new language in a new workplace—a 500-year deficit that is not easily made up—yet today, the gap is closing. Alachua County's pioneers are the sojourner faith troopers of the dark past, accredited with the daily struggles to confront and equalize injustices.

This Black America Series book is a glance into a little-known piece of Alachua County black history. It recounts the struggles, fears, and victories seen through the eyes and told through the words of the people who built this county and lived in it and who look like you and me. Their personal stories and legacy continue to shape lives in Alachua County.

The morals that are shared in this publication and that were instilled in black families from their beginnings contributed to the success of the black ordinary people who are the driving force behind black Alachua County. Black households bonded, sacrificed, and kept families together through the hard times by using their last dollar to send chosen family members north for better times.

Many unsung heroes' stories went unnoticed—some forgotten, some avoided, others completely ignored. Historians concentrating on the bigger picture chose to overlook ordinary history makers who forced change and fought silently and unpretentiously for freedom, justice, and equality. The author identifies one such family, while giving many other Alachua County residents their place in a history long overdue. She is currently researching cemeteries, in search of those great Americans who left their marks but have gone largely unnoticed.

However, this Black America Series living story proves that black history did not begin or end with the civil rights movement, but started long before such history makers as Zora Neale Hurston, Rosa Parks, James Weldon Johnson, and Martin Luther King Jr. arrived.

Divorcing ourselves from our ancestral history minimizes our ancestors' accomplishments. They resisted totalitarianism, standing firm on principles in their fight for liberation.

A great portion of recorded history originated on the shoulders of real history makers, our once-enslaved ancestors. These pioneers played a pivotal role in this area's accomplishments, combining inherent skills with structural makeup. Without their supply of free labor and ideas, Alachua County's history, more likely than not, would be minimized.

In 1865, two years after the Emancipation Proclamation, blacks owned a lot of the property in Alachua County. Property taxes soared, and whites seized the opportunity to capitalize on property once owned by ancestors. More lynchings took place in Alachua County than in any other Florida county seizing black-owned property.

This book, part of Arcadia Publishing's Black America Series, uncovers images from the real working-class people who tilted the scales of injustices to help shape Alachua County's black history.

One

PIONEERS
Movers and Shakers

Richard and Juliann Sams, ages 13 and 14, were kidnapped, roped, and put up for bid on the auction block in Jackson, Mississippi. They were bought by 22-year-old James M. Parchman and were forced to walk barefoot to Archer, Florida, in 1839. Both were separated from Texas and Mississippi families torn apart by the sale, and they never saw their families again. Survival, love, marriage, and 10 children—all self-delivered—later, the Samses created a legacy based on never forgetting the struggles, anguish, and triumphs. Their cultural contributions to Alachua County are immeasurable. Juliann, a freedom fighter who was determined to survive, refused to be broken by slaveholder James Parchman, who saw her as undermining the functioning of the Parchman Farms before taking her hostage. Perhaps the greatest agony for slaves stemmed from the knowledge that one could be sold from family and friends at any moment. Richard Sams (1825–1914) and Juliann Sams (1826–1926) encountered that agony.

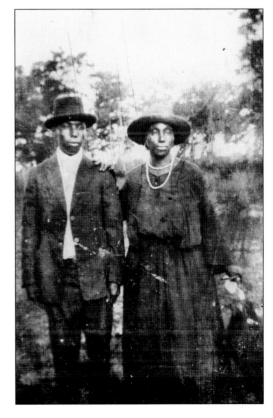

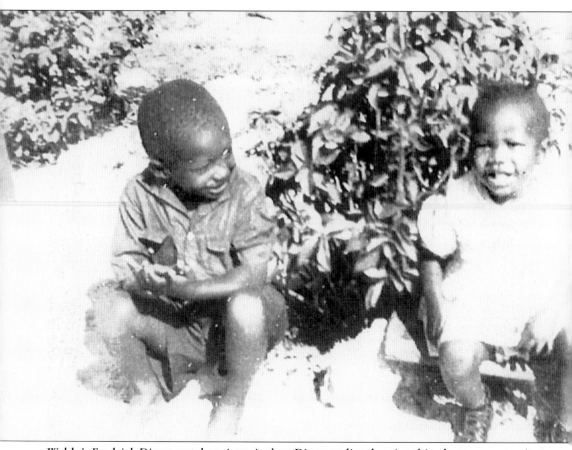

Waldo's Fredrick Dixon watches sister Audrey Dixon radiantly seize this photo opportunity. Unaware of the glamour shot in progress, she shares an accepting smile. In 1866, one year after the Emancipation Proclamation, Mack Dixon Sr. and Florence Adams Dixon (1867–1932) sustained the Dixon legacy. Courage and firmness secured Mack a job at the Waldo Police Department early. Having a job was necessary to provide for a family of 13—Ada Dixon Isaac (b. July 30, 1884), Viola Dixon White (b. April 20, 1889), LeRoy Dixon (1890–1983), Harry Dixon (b. November 3, 1892), Ola Dixon (1894–1908), Luberta Dixon Watts (1896–1981), Mack Dixon Jr. (1898–1981), Inez Dixon (b. December 25, 1900), Ruby Dixon, (1902–1998) Florence Dixon Belcher (1904–1966), Roosevelt "Bubba" Dixon (1905–1980), Samuel "Mann" Dixon (1906–1957), Florida "Pie" Dixon (1907–1950)—in rural, segregated Waldo.

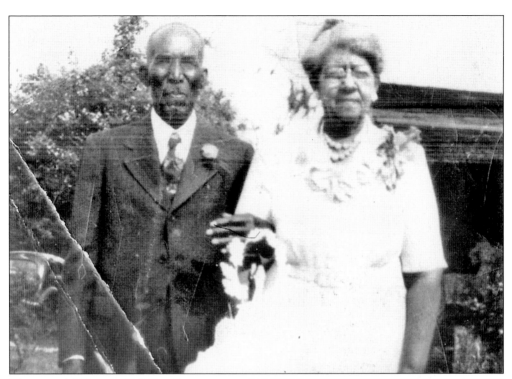

Thomas and Maggie Hall Bradley
Jr. were among founding members
of the Rochelle community. Tom
Bradley's family structure has extensive
generations.

George Vernon, a successful farmer,
arrived in Waldo by train with an aunt
who mistreated him. Later a white family
from Waldo (the Cooks) took him and
raised him with their family. He grew up,
worked on the railroad, and farmed to
provide food for his family.

Lizzie Williams, a domestic engineer, operated a home business for the well to do and took on their washing and ironing. Her husband worked 60 hours a week for 50¢ a day. Her home was a stopover for the Sandhill neighborhood schoolchildren, for whom she baked teacakes each week and provided a cool cup of well water before the long trek home.

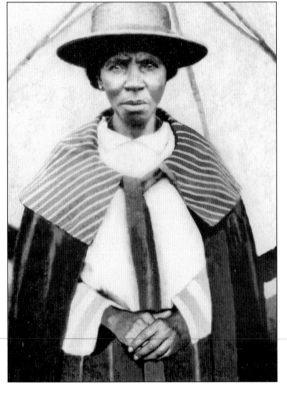

Ellen Butler, a Gainesville native, is great-grandmother to Barbara Sharpe. She established a church quilting group for neighborhood women. She used her masterful skills to create the handmade coat she is wearing in this photograph. She lived to age 103. She confirmed that early inventions and developments began on the shoulders of the courageous slaves who envisioned profits for future generations.

Neal Shaw, a Waldo native, was aware of what would happen to blacks who violated Jim Crow laws, such as drinking from white water fountains, trying to use public restroom facilities, or trying to vote—they risked their homes, their jobs, even their lives. He was grandfather to Mabel and Arthur Vernon, a farmer by trade. In fact, all early settlers were property owners and farmers. He contributed to the shaping of the civil rights movement.

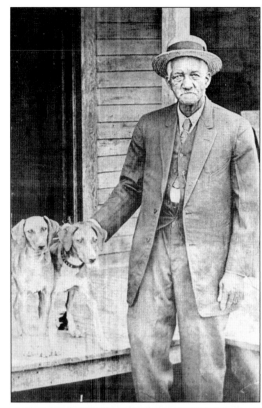

Mollie Pugh, a Windsor native, married John Henry Pugh, a supervisor. Six children were born of their union. Mollie was a midwife, taking care of white expectant mothers traveling from Hawthorne to Starke and Lawtey. Alberta Pugh Nelson is her only living child. Her grandson, Dr. Ernest Nelson, M.D., must have inherited her midwifery skills, as he now lives and practices medicine in Columbus, Georgia.

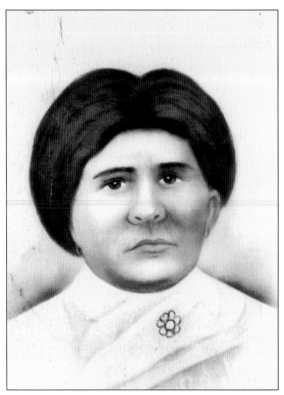

Maggie Drake, a Boardman native, humanitarian, and spiritual guide, knew it took more than beauty to fashion a legacy. Early planning established an educational route for great-grandchildren Rosemary Christy, Carolyn Waites, Jane A. Warren, Patricia Mann, and Jimmy Walker.

Rosa Johnson Braker, a Hawthorne native and homemaker, married Rev. John M. Braker. She was the chairperson of Baptist Young People's Union (BYPU) at New Hope United Methodist church, founded in 1907. Her children, Martha Bennett, Clara Williams, Anna Hill, Cassie James, Geraldine Wyley, Darlene Williams, and John Braker, were actively involved in Sunday school. Recently the surviving membership donated the church to Hawthorne Historical Museum and Cultural Center. Rosa is fondly remembered for walking to church sporting a fashionable parasol.

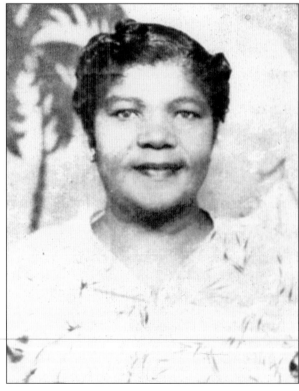

Jennie Sallet Lewis, wife of Gordon Lewis, led by example in her Asbury hometown. She was grandmother to Arthur Jones, a homemaker and Asbury's oral historian. When Jennie and her husband, Gordon, rode the bus together, she was required to sit in the back of the bus.

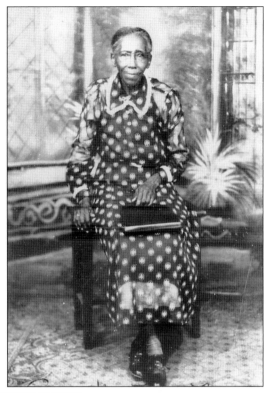

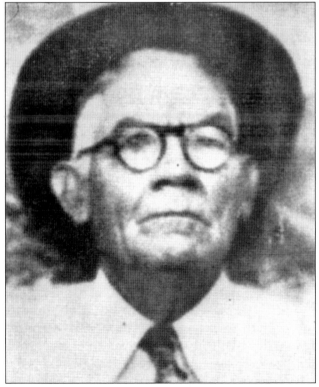

Gordon Lewis, an independent farmer, was instrumental in developing the rural community of Asbury. He and his brother Nelson bought an Asbury farm. Farming was the only work they knew, and they made an honest living selling to local merchants. They owned a gristmill, charging half price for their work, and kept half of the yield as payment balance for service. They did not have to ride on the back of the bus because of their light skin.

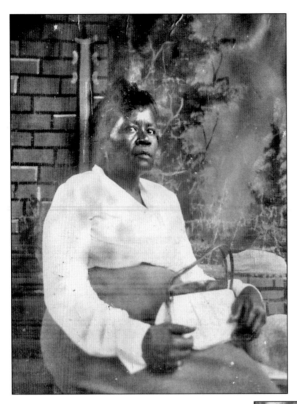

Beulah White lived her life in Christian submission. She spent quality time watching her daughter and son-in-law, Beatrice and J. W. Williams, raise their children. Her grandson Atrice Williams is an army officer who works at the Pentagon, and her grandson Reginald Williams is a former principal at Williston Elementary School.

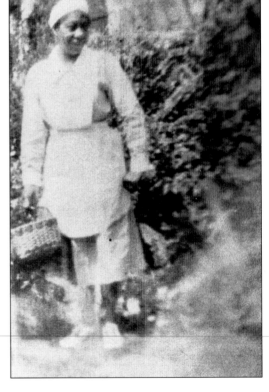

Waldo native Ada Dixon Isaac's legacy speaks to the elevation of blacks in Waldo. Her parents, Mack and Florence Adams Dixon were among the first blacks to disembark in Waldo. She, like other early settlers, worked to support her family and preserve a legacy.

Pearl Shaw Vernon, a Waldo high-society woman, did not work outside the home. Her husband was the sole provider, bringing in enough money from his job as a railroad worker to manage their family.

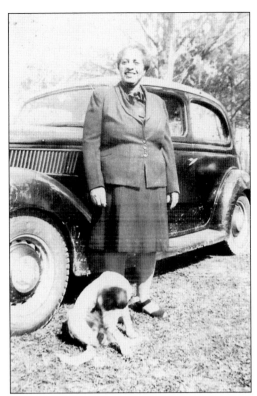

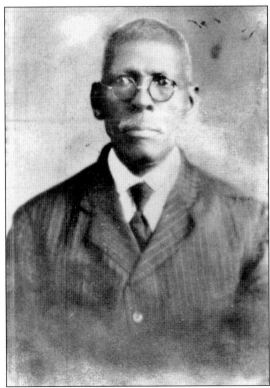

Samuel L. Hendley Sr. was a mail carrier in the black community. His job afforded his family a privileged lifestyle in Gainesville in the early 1900s.

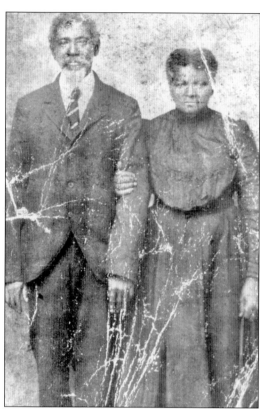

Patrick and Hester Sims Adams were pioneers during a time in which anti–civil rights laws prohibited the protection of black citizens. Farming was an honorable way of life for pioneers.

James McKinley worked hard providing for his wife, Julia, and their children. Their daughter Julia Harper was an educator and the first black teacher to work at P. K. Yonge School.

Two

FARMING
A Way of Life

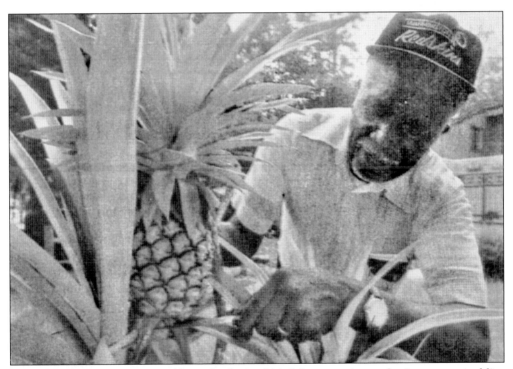

John M. Jenkins Sr. is seen picking the fruit of his labors, a pineapple. As a young soldier stationed in Hawaii, he nurtured a green thumb that is still with him. Back in Alachua County, which has a similar climate, he began planting an array of tropical plants, including avocados, pineapples, and "a little bit of everything." Today Jenkins lives on a farm with his wife, Lizzie, and nurtures an array of animals continuing his farming hobby.

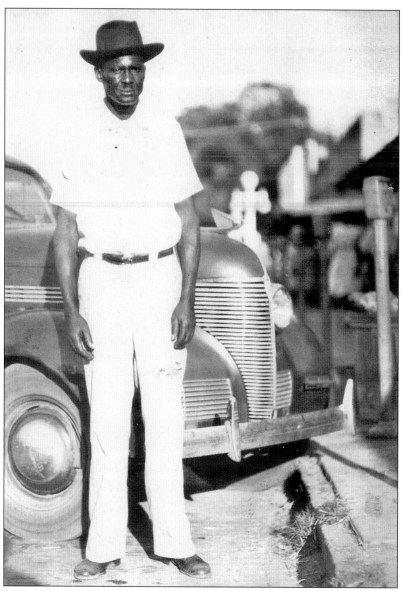

Neither the lean years of the Great Depression nor the lure of fast money to be made in the city tempted Ura Robinson, a farming businessman, to leave his Archer farm. Robinson, now retired at 73; his son; and three of his grandsons keep alive the family farming tradition by working his 223 acres and their nearby 140 acres. In 1977, *Gainesville Sun* staff writer Jackie Levine wrote about the Robinsons' farm. "All my life, that's all I've ever done," Robinson said about farming. "When I was six or seven years old, I was out doing what I could, pickin' cotton to beat the band." His wife of 50 years, Theresa, also spent her early years in the fields. "I had to walk seven miles to work every day in Raleigh [a town near Archer]. We were paid 50¢ a day," she remembered. Today Robinson's property, purchased in 1940, remains connected to his family. His words of encouragement: "Don't ever sell my property because they are not making any more!" Not many people farm for a living anymore, but for Ura, farming remains the most important occupation in the world, and his grandsons continue the farming legacy. Robinson is pictured with his first car, a 1942 Ford.

This pen was used for cleansing radicals and parasites from hogs before they were slaughtered. Hogs eat anything, including their young piglets; therefore, penning and watching them for a week was a method farmers used to cleanse them.

The slaughtering hog depot is versatile, handling more than one job. The kettle is used for syrup making, crackling cooking, crab boiling, and heating water.

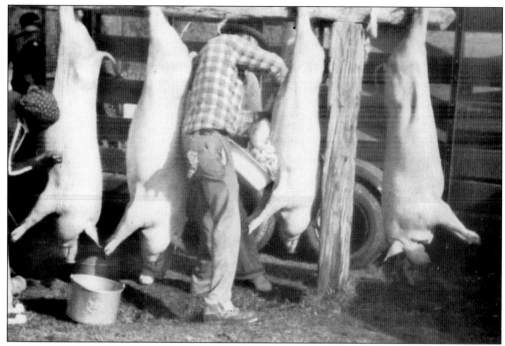

Farmer Ura Robinson demonstrates the mechanics of preparing a hog for consumption and marketing—shoot in the head, cut throat to bleed, submerge in boiling water, remove hair by scraping, and hang by hind legs for blood drainage. The belly is opened up to remove all internal parts, and then the carcass is moved to the butcher's table for dissecting.

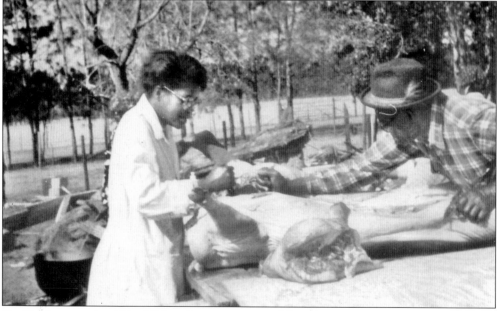

Ura Robinson trained his children in every aspect of farm living. Lizzie Jenkins watches and helps her father cut apart a hog, readying it for cold storage, processing, and supermarket distribution. Pork shoulder is used for roast, ham grinding for breakfast sausage or picnic ham, backbone for pork chops, and bacon is made from the hog's belly.

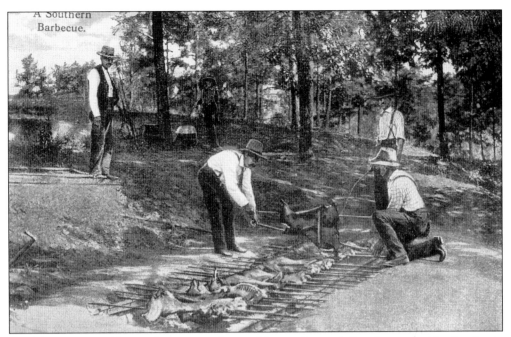

A Southern Barbecue.

Rural farmers raised livestock, crops, and vegetables, ending each farming year with a Southern-style barbecue for their hired helpers, sometimes inviting the entire neighborhood. Ending an old farming year meant opening a new farming year with little rest in between.

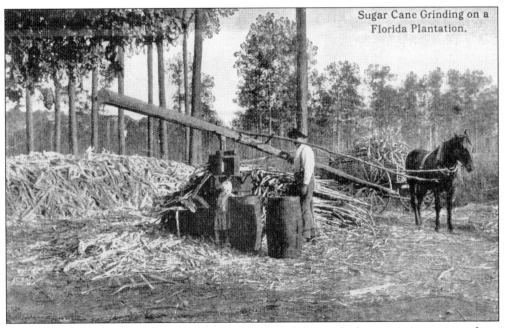

Sugar Cane Grinding on a Florida Plantation.

Sugarcane grinding on a Florida plantation is a cultural thing. The horse awaits a gesture from the laborer to start movement. The stacked sugarcane lay ready for grinding after shocking and stocking. Making syrup from sugarcane is a tradition still active on some Alachua County farms, such as those owned by the Robinsons and Pennys.

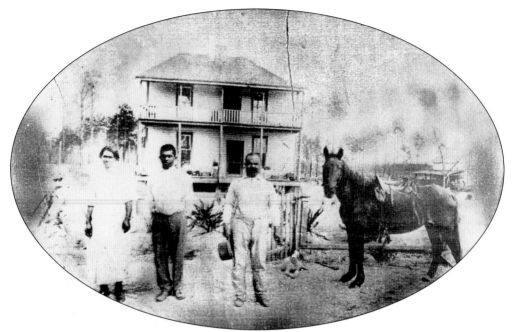

Josh Nelson was a Hawthorne farmer who owned more than 300 acres. He was an entrepreneur and a sharecropper, but he did not sharecrop for white farmers; black farmers sharecropped with him. Pictured, from left to right, are his wife, Ella Jones Nelson; his son Ernest Nelson; Josh Nelson; and his horse Galston (Josh's exclusive mode of transportation). Around 1918, the Nelsons posed in front of their two-story home for this photograph. The family contributed to shaping of the Alachua County economy and is still in possession of the property.

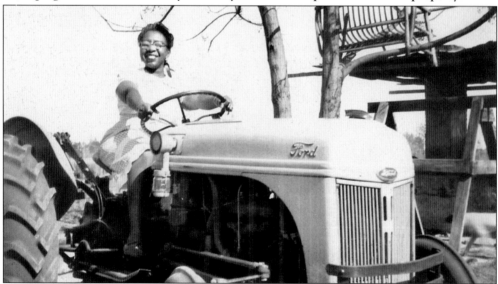

Johnny Cotman used a mule for hand-plowing on Josh Nelson's farm, and he later purchased a new tractor to use on his own farm. In this photograph, Cotman's wife, Ruby, shows off her skill at driving their new tractor. Farmers planted enough to barter with neighbors and provide for family. Johnny farmed livestock as well as produce and vegetables, which he sold to area merchants.

Pictured here is Mable Hall, a Rochelle educator whose parents, Ed and Ellen Bradley Hall, realized the importance of attending Bethune Cookman College early in the 1900s. Her first teaching job was in Archer. Her cousin Charlie L. Brown, born in Rochelle, was Archer's former Negro supervisor of education; therefore, positioning a job for her in Archer was easy enough.

Mable Hall built her first home in Rochelle around 1948. During this era, her home lists among the state-of-the-art. Her contractor worked a regular job, and each evening after work, he toted lumber to build her home, one piece at a time.

Friends of the Richard Bradleys envision a National Register of Historic Places nomination for the Bradley home. It was built around 1908. The Bradley legacy extends for generations. Niece Bennie Jean Nelson Edwards, an artist, sells drawings of the Bradley home.

Canning is a rural tradition perfected in each black Jonesville household. Farmers planted enough vegetables to share at the end of each crop season for canning and preserving. In addition, jellies and jams made from fruits and wild berries were canned.

Three

GOD IS
Faith, Hope, Clarity

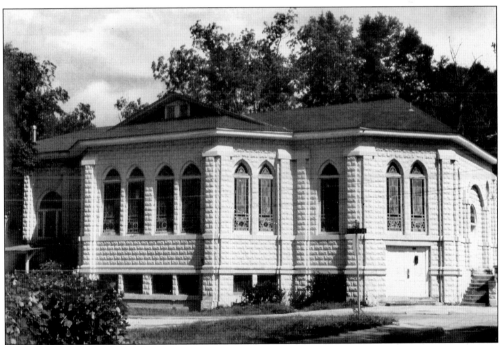

Friendship Baptist Church and other black churches were institutions where slaves would hide, teaching would happen, and networking developed. The African American church is one of the most influential institutions in Alachua County. Based on faith, hope, and clarity, the black church has survived. Friendship organized in 1888. In 1891, Rev. Richard Shivery deeded land to the church's trustees. In 1911, the congregation built the existing structure. It received the 1997 Matheson Award for historical and heritage preservation of Alachua County.

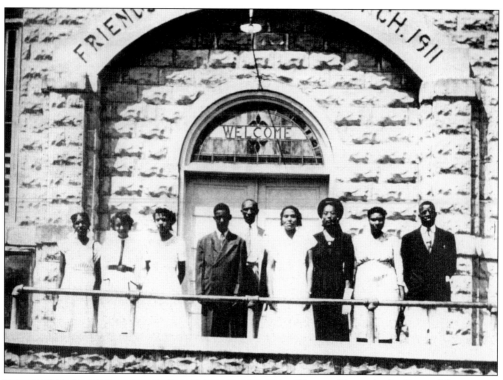

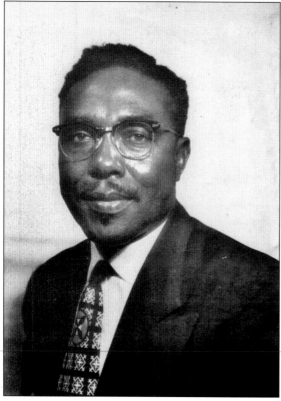

Pictured here is the Friendship Baptist Church Sunday school class in the early 1900s. Pastor Shivery was a trustee of the Union Academy School and member of the Gainesville City Commission in 1882. He also was pastor of Mount Moriah Baptist Church, the first African American church to organize in Gainesville.

Rev. William Arthur Miles founded First Baptist Missionary Baptist Church and was pastor during the construction of two other churches, St. Joseph Baptist Church of Archer and Hopewell Baptist Church of Gainesville. Rev. Miles was also pastor of Mount Moriah Baptist Church and is the father of Arthur, Andrew, Isaac, and Rev. Veronis Miles.

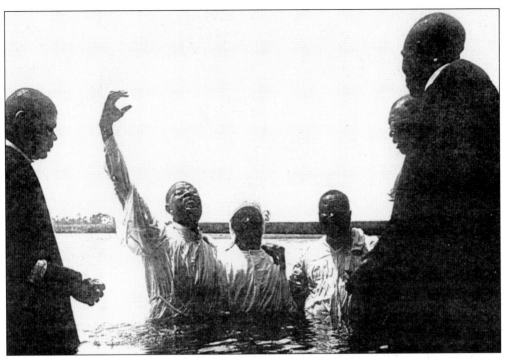

Pond baptisms on early Sunday mornings echoed gospel singing across the water waves, resonating into neighboring communities with choruses of "Wade in the water, wade in the water, children, wade in the water, God's going to trouble the waters."

The tune "Take Me to the Water to Be Baptized" was heard at outdoor pond baptisms and indoor church baptisms at St. Joseph Baptist Church. Pictured from left to right, siblings Demetri, Tykdra, and Cheryl Robinson are waiting for a Sunday morning baptism.

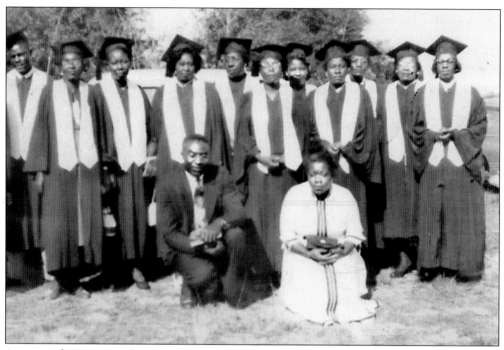

A concert draws a crowd at Springhill Missionary Baptist Church annual Black History Month celebration. Deacon Burnice Gaskin is choir director in this *c.* 1960 photograph.

Rev. Horace Blount, former pastor of Mount Carmel United Methodist Church in High Springs, organized one of the first youth groups at the church.

Hopewell Missionary Baptist Church in Gainesville was founded in 1899 by Rev. J. R. Brown and rebuilt in 1956 by the late Rev. William A. Miles.

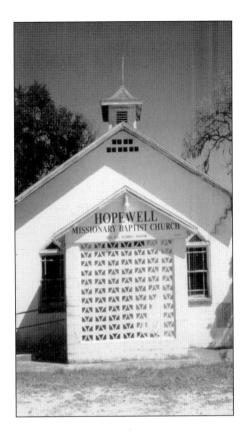

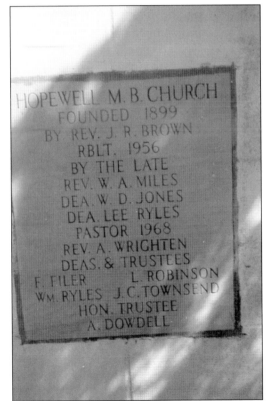

The Hopewell cornerstone informs the community of its historic significance. Rev. William A. Miles, Deacon W. D. Jones, and Deacon Lee Ryles served as officers of the church. In 1968, Rev. A. Wrighten served as pastor with deacons and trustees F. Filer, L. Robinson, William Ryles, J. C. Townsend, and honorary trustee A. Dowdell.

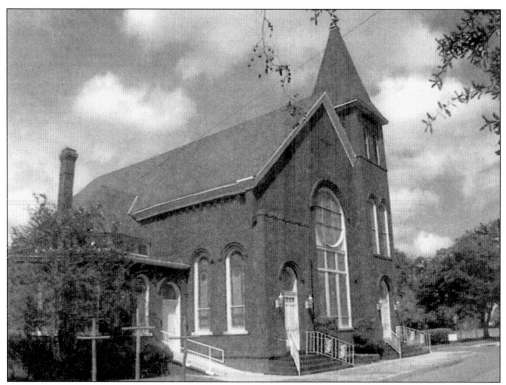

Mount Pleasant United Methodist Church organized in 1867. Charles Brush purchased and donated the property in 1883. The church was conformed to brick in 1887 and was destroyed by fire 1903. The present building is a 1906 structure. It received the 1997 Matheson Award for historical and heritage preservation of Alachua County.

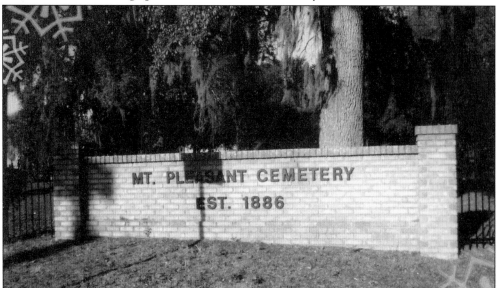

Mount Pleasant Cemetery was established in 1886 and is the final resting place for many Gainesville black families. The present location and surrounding properties once belonged to black Alachua County citizens.

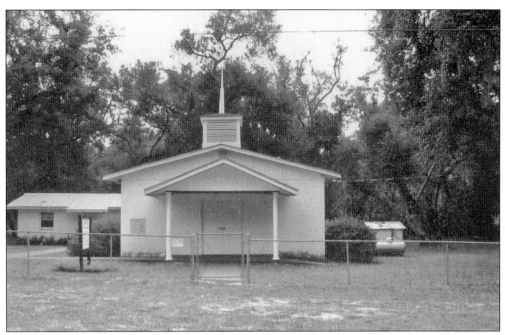

Wacahoota, Florida, has been home to Hopewell Baptist Church since 1870. Serving as pastors were Rev. Prince Murray, Rev. Squire Long, Rev. Spencer Long, and Rev. Castor Nelson.

Hopewell Baptist Church's historical marker honors the legacy of its leadership. Included are Ransom Dukes, Mitchell Dukes Sr., John Bryant, Mitchell Dukes Jr., Dave Turner, Bethum Batie, Zach Simpson, Willie Harris, Mariah Dukes, Beatrice Batie, Lillian F. Haile, Martha Calhoun Dukes, Judy T. Long, Cherry Ferguson, Maggie F. Turner, and Sallie W. Peterson.

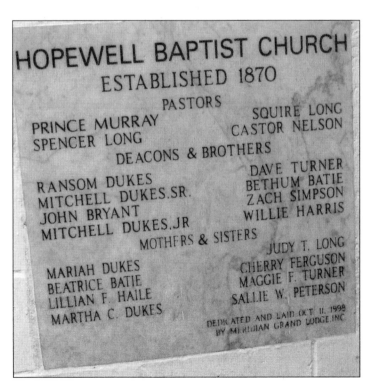

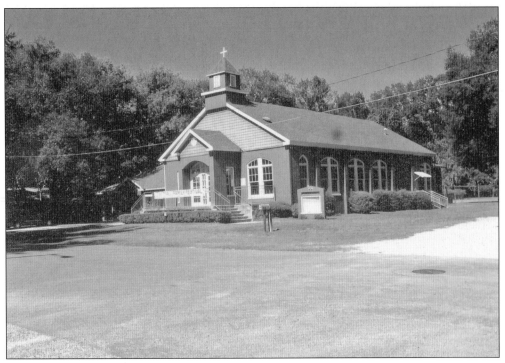

Johnson Chapel Missionary Baptist Church was founded in 1917. Rev. C. J. Johnson served there longer than any other pastor. Rev. Seale is the current pastor and is married to Cynthia Rowe Seale.

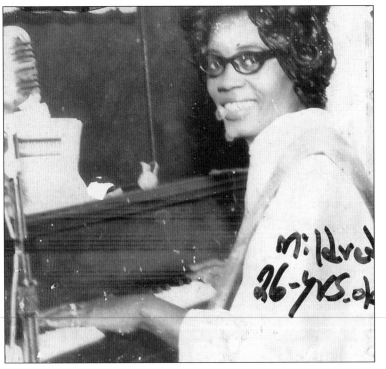

Mildred Dewberry Oliver, an outstanding local artist, musician, and singer of the gospel has resided in Gainesville (Sugar Hill neighborhood) for more than 50 years. She is the niece of famous gospel singer Mahalia Jackson and continues to spread spiritual messages through gospel singing.

Bishop McKnight has been pastor of Gainesville Church of God by Faith ever since December 1961. Under his leadership, a new edifice was built in 1973, and the church was renovated and expanded in 1990.

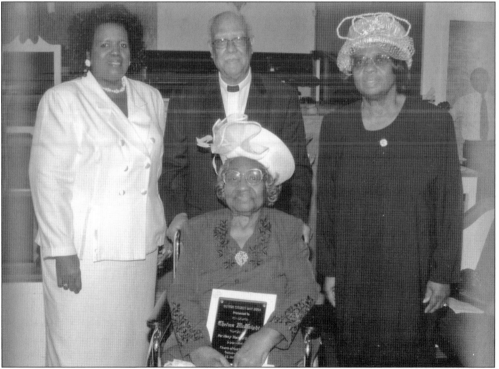

The Church of God by Faith honored Thelma Burnette McKnight, recognizing more than 50 years of dedicated and outstanding service. Also pictured, from left to right, are daughter Wilma McKnight, Bishop James E. McKnight, and Jessie McKnight.

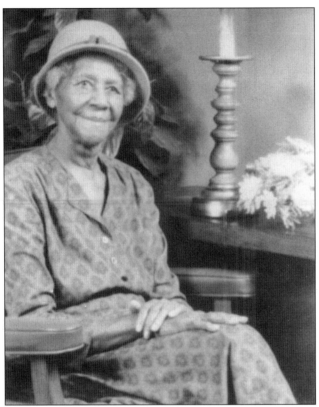

Maggie Gill's family was among the founding members of Micanopy. The ingredients that manufactured healthy neighborhoods started in the church and school and were built on morals encouraging and providing education opportunity at every level.

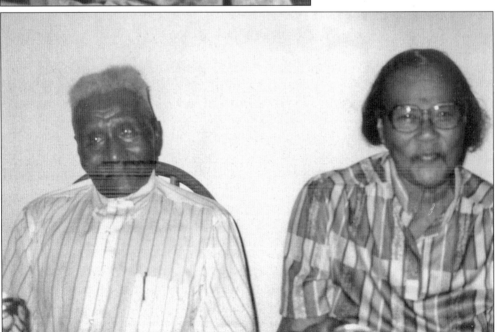

Nathaniel and Rebecca Gill Hall, Rochelle residents since the 1900s, worked hard making their community one of historical significance. He was a successful farmer, and she worked in the Alachua County lunchroom program. Maggie Gill is Rebecca Gill Hall's mother.

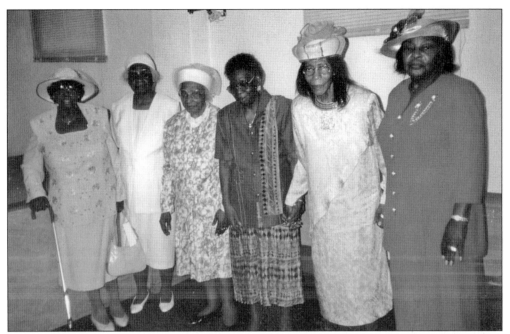

High Springs Matriarchs, all churchgoers ages 90 and over, inevitably have worked consistently to make High Springs a partner in helping the community meet new and growing challenges. Collectively, they shared more than 500 years of wisdom in homes, schools, and churches, maximizing growth and improvement for their neighborhoods. Pictured from left to right are Mattie Williams, Martha Jane Wilson, Annie V. Cromartie, Pearl Anderson, Marie Jones, and Cora Williams.

Leroy and Isabella Terry Robinson Sr., lifetime Archer natives and independent farmers, worked hard on their home. Prior to the 20th century, the typical American family lived on a farm, raising livestock for food.

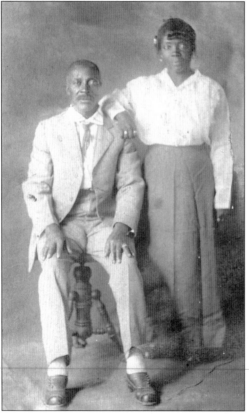

Henry and Eula Mae Robinson Penny Sr. raised nine children on a farm, making enough money to send five daughters to college. Most black pioneers went to school only three or four months out of a year because of anti-education laws; however, their comprehension levels equaled that of the masses. Parents' goals for their offspring were high.

Many hardworking movers and shakers went unnamed and unnoticed. While this Alachua County couple is unidentified, the image is representative of the strong black pioneers who established a foundation for future generations.

Willie and Edna Rowe Brown moved to Gainesville from Archer in the 1950s in search of quality living and a better education for their children. They are the parents of Willie Jr., Alex, Elouise, Virginia, and Vernell Brown. Willie Sr. worked for the City of Gainesville.

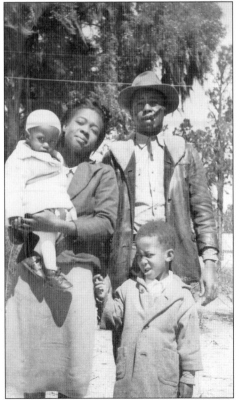

Having a grandparent in the home and caring for the extended family is a tradition in the black family. Johnny and Ruby Cotman are prime examples of this tradition. Pictured from left to right are Lynn, Ruby, Johnny, and Benjamin Cotman.

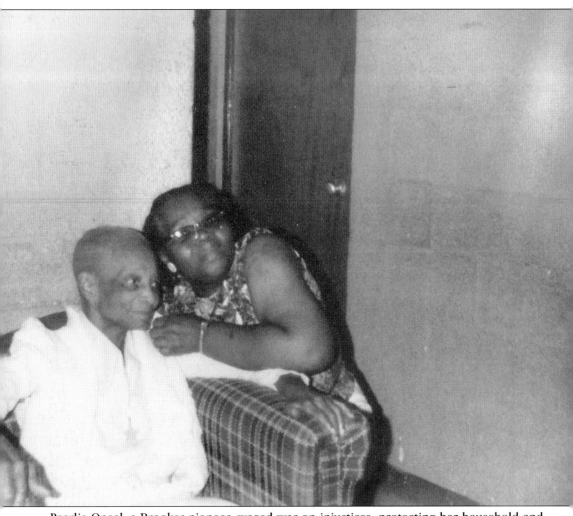

Pearlie Oneal, a Brooker pioneer, waged war on injustices, protecting her household and neighborhood. Oneal's husband did not allow her to work in anyone's home.

Four

EDUCATION
From Homeschooling to Public Schools

Homeschooling blacks is not new in Alachua County. It was a part of a daily routine. Not even Jim Crow laws could prevent skilled academic leaders in each community from educating their own. A degree was not necessary where common sense reigned. Reading, writing, and arithmetic taught to the beat of a history stick defined success. Learning was the ultimate goal in every black family. Later Masonic halls and churches housed teaching tools. All parents participated in breaking learning laws in black Alachua County.

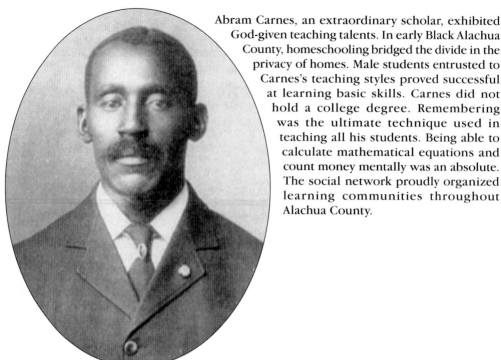

Abram Carnes, an extraordinary scholar, exhibited God-given teaching talents. In early Black Alachua County, homeschooling bridged the divide in the privacy of homes. Male students entrusted to Carnes's teaching styles proved successful at learning basic skills. Carnes did not hold a college degree. Remembering was the ultimate technique used in teaching all his students. Being able to calculate mathematical equations and count money mentally was an absolute. The social network proudly organized learning communities throughout Alachua County.

Addison P. Brown Sr. was among Carnes's first homeschooled students. Parents paid 25¢ for weekly teaching.

Allen Quinn Jones was the last principal at Union Academy and the first principal at Lincoln High School. A bond issue was passed in 1920 to build two new schools in Gainesville—Gainesville High School for white students and Lincoln High School for black students. Both were red brick schools, similar in size and facilities. In 1923, students studied through 12th grade. Decades later, in 1956, with Jones still principal, Lincoln High moved to a new campus, 1001 Southeast Twelfth Street. It closed in 1970, however. Among the first graduating class of 1957 is the author of this Black America Series book. The old campus became home to A. Quinn Jones Elementary School, named in Jones's honor.

The A. Quinn Jones legacy continues. Jones devoted his life to ensuring that blacks in Gainesville and in Alachua County knew the power of education. Jones worked as a water boy in a tobacco field, earning as much as $1.25 per week. With his promotion to curing tobacco in the barns, his wages soared to $5 per week. Later, two towns away from his Quincy hometown, Jones became headwaiter for the faculty at Florida A&M College. It took the income from these jobs for Jones to obtain a high school education. Jones earned a bachelor's from Florida A&M College.

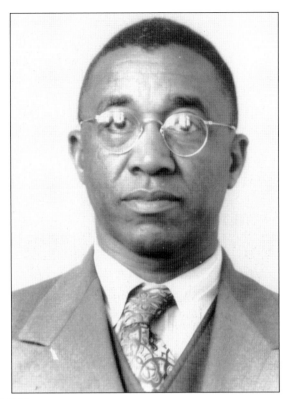

Fredrica Jones, an English teacher at Lincoln High School in 1956, was the wife of A. Quinn Jones Sr. and the stepmother of Oliver Jones.

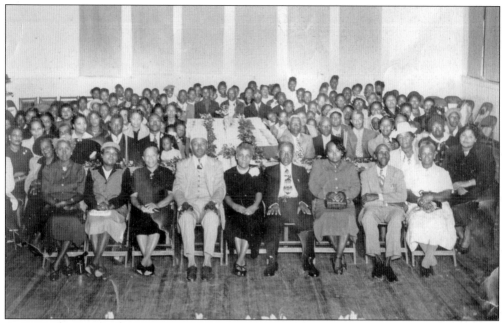

Archer Negro High School was founded in 1937 after two years of planning and construction. The Archer men were compelled to raise funds to purchase 10 acres of land for the building. This 1948 PTA meeting is symbolic of parent involvement. Parents cherished the right for learning because not being allowed more than four months of schooling themselves, they made certain their children received a better education.

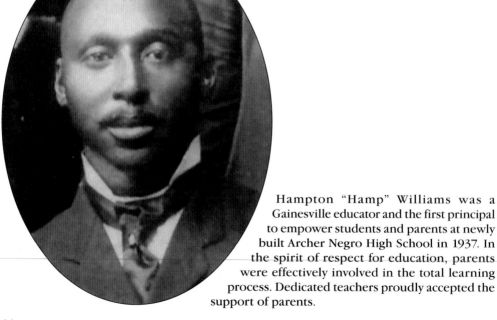

Hampton "Hamp" Williams was a Gainesville educator and the first principal to empower students and parents at newly built Archer Negro High School in 1937. In the spirit of respect for education, parents were effectively involved in the total learning process. Dedicated teachers proudly accepted the support of parents.

Archer Negro High School PTA president Theresa Brown Robinson crowns her brother-in-law, Tom Robinson Sr., for bringing in the most money for the PTA fund-raiser. Several Archer stewards served as PTA president over the years, including Mittie Clayton, Mabel Reddick, Lovett Brown, Elsie Nubin, Marie Irons, Ethel Rowe, Carrie Nattiel, Lillie B. Brown, and Clytha Penny.

Pictured here is Supervisor of Education Charlie L. Brown Sr. Not shown is Willie Williams, another supervisor of education. Both men received endorsements from the Men of Worth organization, churches, and Masonic auxiliaries. Education was a priority for students in their neighborhoods.

David Williams Sr. is the son of Negro Supervisor of Education Willie Williams Sr. and is the father of Oretta Williams Duncan. He is a graduate of Edward Waters College in Jacksonville, Florida.

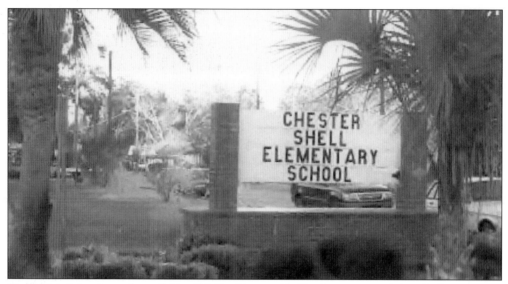

Shell High School was founded in 1926 by Chester Shell, who contacted the Alachua County School Board and requested a school for the black children of Hawthorne. He was told to raise half of the necessary funds and the school board would match the funds to build a school for Hawthorne's black children. He raised the money, and his lifetime contribution is in the success of initiating and cofunding Shell High School. Before integration, the black students attended segregated Shell High School. Now called Chester Shell Elementary School, the facility serves a diverse group of students today.

During the early part of the 20th century, black children in Hawthorne went to school only two to three months each year. There was no school building for them, so classes held in private homes, in churches, and in an old Masonic hall owned by the black community denoted success. Chester Shell was a man of wisdom, envisioning a school for black children of Hawthorne.

Ernestine Nelson Walker was the first Bethune Cookman graduate and alumna from Alachua County. A graduate of Chester Shell High School in Hawthorne and an Alachua County 39-year career teacher, she is also the granddaughter of Josh and Ella Jones Nelson.

Magnolia Bradley Jackson was the last principal at Rochelle Elementary School for Black Children, built in the early 1900s. A resident of Rochelle and a career educator, she attended Shell High School and later returned to the community.

47

Albert L. Mebane High School was founded in 1956 and was a school where curriculum planning and learning surpassed the sports activities. Clayton Whitfield was the first principal. Since integration, it has served as a middle school.

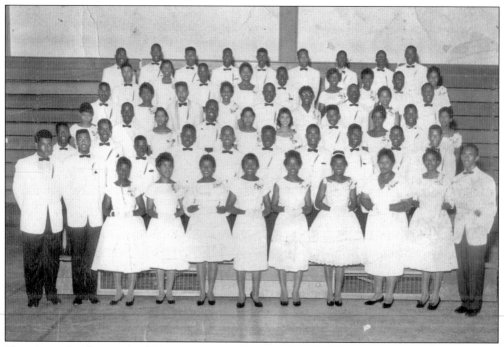

The class of 1961 was the fifth graduating class from historic Albert L. Mebane High.

Johnny Cotman was Archer's first bus driver. He used his personal truck to haul children from his side of town to Archer Negro High School. However, over in Alachua, Willie D. Burgess purchased a school bus from Camp Blanding during World War II, met with Albert L. Mebane, and negotiated hauling the children who were walking at least 10 miles to school. They reached an agreement, "a handshake," and Burgess's son Edward became the first black bus driver in Alachua. His monthly pay was $125, including gas and maintenance.

Ceola Palmore Watkins grew up in High Springs. She finished high school and enrolled at Bethune Cookman College, earning a degree in elementary education. Her widowed mother raised five children after her husband was violently killed in 1925. Watkins never saw her father, but she went on to become a career teacher in Alachua County for more than 30 years and a dedicated member of Mount Carmel United Methodist Church. She is the proud mother of Dr. Clyde Watkins Jr., M.D.

Mattie Hendley was an elementary school teacher for more than 50 years. She was a founding member of the Civic Club, Excelsior Matrons in 1941.

Dona Hendley Coward retired from the Alachua County school system a few years ago. She is the wife of educator and commissioner Tom Coward and the daughter of Samuel L. and Mattie Spikes Hendley Jr.

Tom Coward (second row, right), director of student council, organized creative ways and means to meet the needs of all children. He set challenging goals, kept education alive, and preserved Lincoln's legacy.

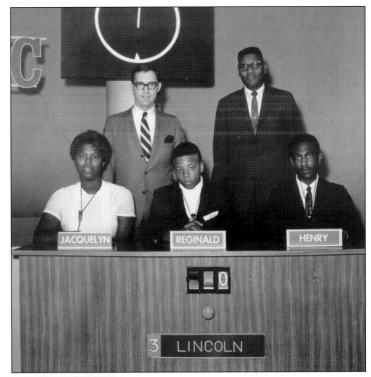

Robert Ayer Jr., an ingenious Archer High School and Lincoln High School educator, donated more than 30 years to teaching in Alachua County. He is the proud father of a son and daughter who are ophthalmologists in St. Petersburg, Florida. He is the son of Dr. Robert Ayer Sr., M.D.

Joel Buchanan is the founder and chairman of the Afro-American Culture Historical Board. This organization researched the Liberty Hill Negro School, resulting in placement on the National Register of Historical Places. Liberty Hill School is owned by the Liberty Hill Missionary Baptist Church family. Local students who attended, walking miles to get there, included the Bostons, Smiths, and Duncans.

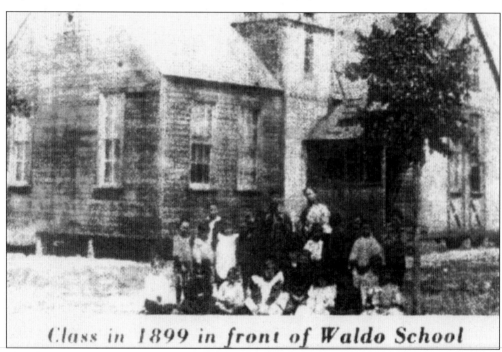

Class in 1899 in front of Waldo School

Seen here is Waldo's one-room schoolhouse for black children built in the late 1800s. This 1899 photograph represents community learning for all grade levels. Early Waldo settlers and their children attended this school.

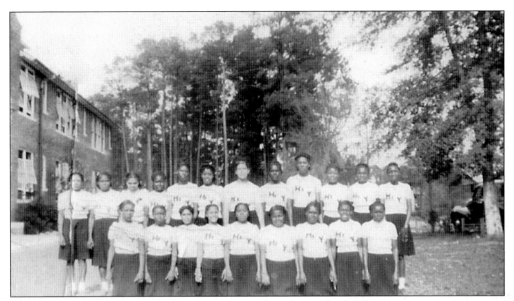

Members of a Waldo 4-H youth club tidy up for photo shoot after a camping excursion. The Future Farmers of America and the 4-H club helped train black youths in the areas of gardening, canning, and homemaking. Local agents used these activities to improve the living conditions in black communities during the period of 1920–1965. Waldo's schoolhouse is in the background.

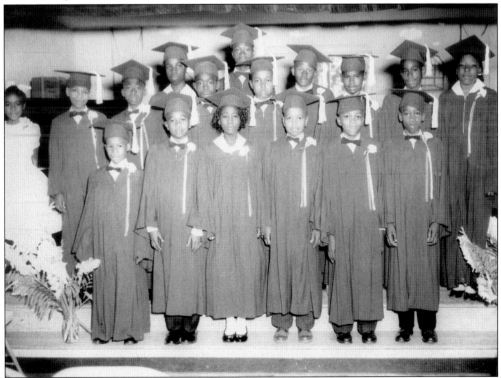

Waldo school graduates another class. Susie Session Mosley (far left) is wearing a white dress. She is a Gainesville entrepreneur.

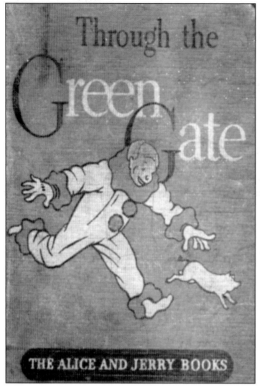

THE ALICE AND JERRY BOOKS

Miss Lizzie

Someday you may go to Friendly Village. Of course, when you get there, you will want to see all your old friends, Alice and Jerry, Bobby and Billy, and Paddy and all his pets.

You will want to call on Mr. Carl, and say "Hello" to Mr. Andrews in his fruit store on River Street.

Maybe Cobbler Jim will let you sit on the end of his workbench, and talk to his old black cat while he mends your shoes.

In 1941, new copies from the Alice and Jerry Books series were purchased for white students. Seven to eight years later, the same books were passed on to black schools for use. "Miss Lizzie," the storybook teacher, lived in Friendly Village. From *Through the Green Gate*, the page above right illustrates that abused books passed on to Alachua County black students were filled with epithets, markings, and torn pages. In spite of the disrespect, students still performed at very high levels. Colin English was Florida's state superintendent of public instruction in 1941.

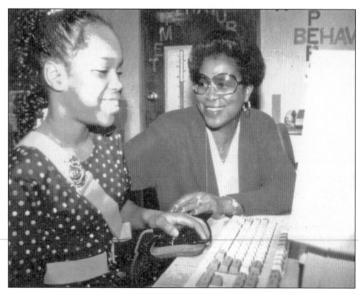

A real "Ms. Lizzie" lives on a real Archer farm and was inspired at a young age reading about Miss Lizzie, the storybook teacher. Lizzie Jenkins read from the Alice and Jerry series in 1948; in spite of page damage throughout the book, she learned to read. Jenkins enjoys laughing with student Stephanie McCray at Newberry Elementary during the 1991–1992 school year.

54

Wilma Simmons, pictured center right, upholds her family tradition by leading a third generation of educators. Keeping alive the dreams of her mother, Emma Mitchell, Wilma introduced Myra Simmons to educational opportunities, continuing the Mitchell/Simmons legacy. Wilma earned double master's degrees at the University of Florida while working.

Pictured from left to right are members of four generations of Nelsons in Rex Hill (Hawthorne), Florida: Ella Jones Nelson, Betty Nelson Howard Mobley Bennett (standing), Gussie Nelson Walker, and Gail Renette Mobley. A fifth-generation Nelson living in Atlanta plays professional baseball.

Eliza Newton Haines Thomas Bell was born November 7, 1878, in Archer to Mr. and Mrs. Zack Newton. She was educated at Long Pond and Gainesville. At age 23, she married Amos Haines, an Archerian. She moved to Gainesville in 1913 and envisioned a need to mentor children. She called together her daughters, grandson, and friends to share her vision. Bell's Nursery Daycare Center became a reality in 1954.

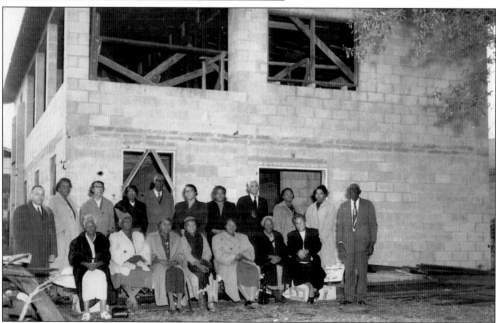

Bell's Nursery Daycare Center's executive board of directors was established to serve the community. The members worked hard developing the curriculum, policies, and schedules to meet the anticipated needs of parents. Bell was a devout member of St. Paul CME Church; therefore, her church rallied in support of her initiative to open a nursery for working neighborhood parents.

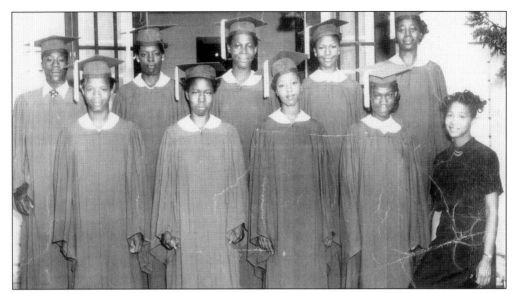

Members of the Archer Negro High school graduating class of 1954 included, from left to right, the following: (first row) Heddie Means Witherspoon, Louise Lundy, Catherine Williams, Rosetta Crawford Robinson; (second row) Oscar Rollins Sr., Agarene Hunt Nattiel, Claretta Bailey, Ernestine Penny Jefferson, and Dorothy Mae Robinson Samuel. Pictured on the far right is Nancy Green Coleman, class sponsor.

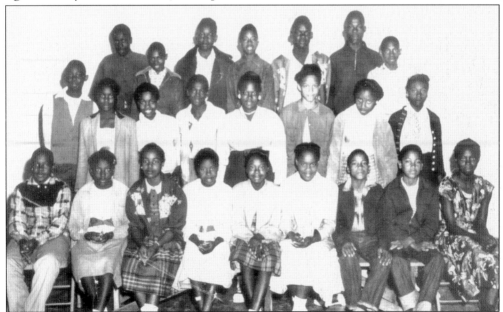

The Archer Negro High School sixth-grade scholars of 1963 included the following, pictured from left to right: (first row) Walter Calhoun, Rosa Lee Brown Rutledge, Bertha Wiggins, Birda Mae Brown Witherspoon, Vilean Means, Queenie Mae Rollins Rutledge, James Nubin, Henry Earl Cotman, Elouise Brown; (second row) Harold "Bubba" James, Rosa Spann, Damean Rollins, Richard Bailey, Roneda Hunt Moss, Annie Mae Williams, Estella Robinson; (third row) unidentified, Henry Strange, unidentified, Johnny Brown, Richard Griffin, unidentified, and Rubin Nattiel Jr.

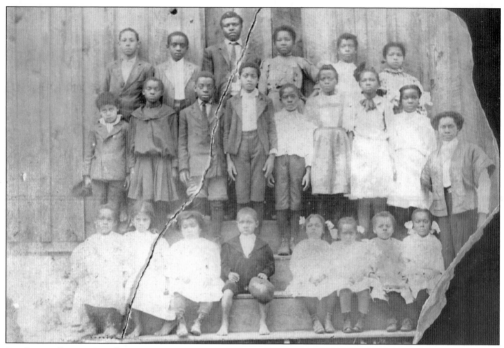

In the early 1900s, the attentive students look to their teacher for leadership training. The background shows the school's batten panels on their one-room schoolhouse. (Courtesy of Carrie Johnson Parker-Warren.)

Twins Allie and Alberta Shaw grew up in Waldo and attended high school in Gainesville. They were very involved in community- and church-related activities.

Patricia Dixon, an engaging, dedicated educator, has taught school for more than 25 years. A High Springs teacher and mother of two boys, she spends after-school hours taking them to activities.

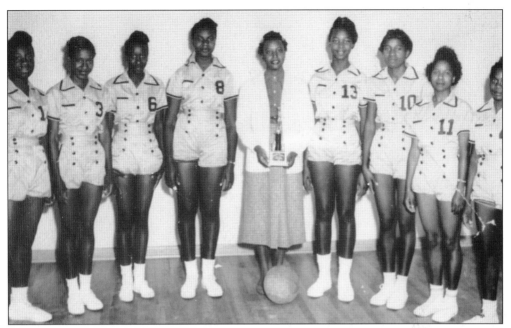

The Archer girls' basketball team was one of the best in its tristate district. They won the 1955–1956 Alachua County Girls' Basketball Tournament, and coach Doris Jones proudly accepted the team's success. Teammates, pictured from left to right, are Ernestine Hall Daniels, Oneder Hunt Langston, Versa Campbell Rhim, Pearlie Penny Brown, Henrietta Bailey, Lizzie Robinson Jenkins, Gertrude Miles Muerrel, and Daisy Hale Rollins.

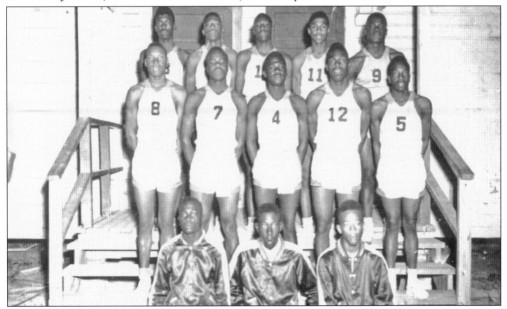

The Archer boys' basketball team enhanced team spirit in the physical-education department. The coaches were L. C. Franklin and Nathaniel Hankerson. Pictured from left to right are (first row) Ivory Miles, Norman Brown, and John Rubin Cotman; (second row) Ladis Ross, Louis Rollins, Jack Spann, Willie Lee Nattiel, Harry Nattiel; (third row) Freddie Crawford, Walter Hunt, Therom Nubin, Chester Buchanan, and unidentified.

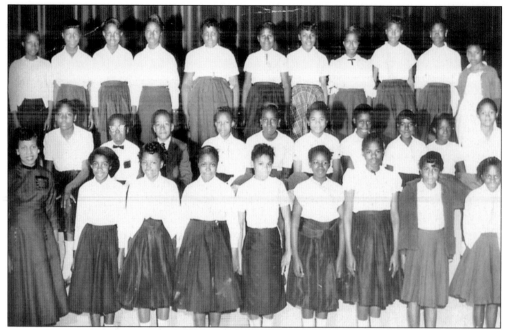

The Williams Elementary School chorus encouraged community relations among proud, supportive parents. Annual concerts celebrated the year's accomplishments. Yvonne Rawls was the music department director.

Alachua County lunchroom workers proudly reported to work daily dressed to impress. They prepared food for every student coming through the line, paid or unpaid, even if it meant reducing portions. School administrators did not ask questions because they understood the rationale. Compassion meant feeding the hungry.

Lincoln's 1949 High School football team will always be remembered in the history of Lincoln High School sports. Coaches for the Lincoln Terriers have included Bob Jones, Ray Washington, Bob Acosta, Jesse Heard, and T. B. McPherson.

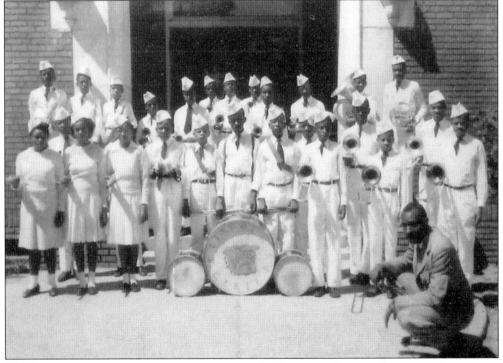

Lincoln High School's talented band was under the direction of Jerry Miller, music-department head. The school participated in county and district competitions, winning several awards of recognition.

Andrew Mickle was a noted teacher in the tailoring department at Lincoln High School. He worked many years as an educator and swimming coach. The Andrew Mickle Pool is named in his honor. He continues to volunteer in the community, serving on several boards. He is married to Catherine Mickle and is the parent of Alachua County's first African American judge, Stephan Mickle.

Catherine Mickle, a notable teacher, left successful imprints on Alachua County students before retiring. All students felt included and were eager to learn. She is married to Andrew Mickle and is the parent of veterinarian Darryl Mickle.

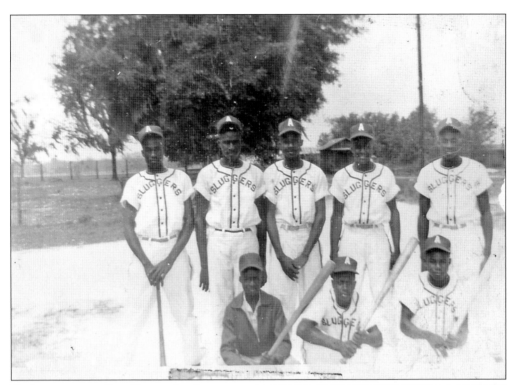

Under managers Sam Brown, Louis Penny, and Eddie Williams, the Archer Sluggers baseball team was established in 1954. Pictured from left to right are are (first row) Richard Strange, Charles Strange, and Willie James Robinson Sr.; (second row) Isaiah Robinson, Leroy Robinson Jr., Johnell Robinson, Nathaniel Robinson, and Eligha Robinson Sr.

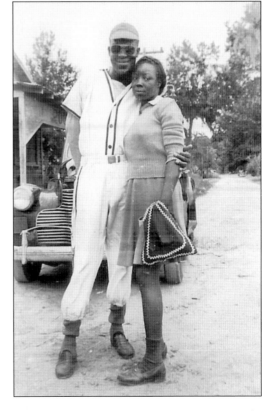

The Waldo baseball team participated in the county and district meets. Community baseball gatherings attracted and entertained the whole family on weekend outings.

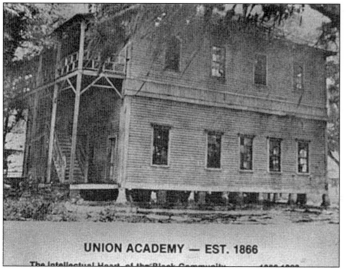

UNION ACADEMY — EST. 1866

The Intellectual Heart of the Black Community

In 1866, Union Academy was established. Union Academy was the intellectual heart of the black community in Gainesville and Alachua County for almost 60 years. Built by the Freedmen's Bureau and with the support of the George Peabody Fund and northern friends, it covered elementary through high school. The building was originally one floor, but a second floor added in the 1890s meant more students.

In 1917, Julius Rosenwald, president of Sears, Roebuck, and Company, initiated a school-building program that was to have a dramatic impact on the face of the rural South and in the lives of its black residents. Through the Julius Rosenwald Foundation, more than 5,300 schools, shop buildings, and teachers' houses were built by—and for—blacks across the South and Southwest, until the program was discontinued in 1932. The Rosenwald School program has been called the "most influential philanthropic force that came to the aid of Negroes at that time." In all, the Rosenwald Foundation contributed more than $4.3 million to construct schools across thee regions, and more than $4.7 million was raised by blacks to build the schools. Local teacher Naomi McDaniels Williams, attended a Rosenwald school, wherein they recently held a class reunion, keeping his indelible mission alive.

Five

CIVIL RIGHTS
Movements

"Standing at the doorway to the future, before flicking off the light and saying goodbye to the past, let us steal one last backward glance into the old room. A last, over-the-shoulder look at Alachua County in the 1800s and 1900s and the events that helped bring us to the thresholds that we are about to cross. In a quick scan of the space that holds this century's local history, a thousand ephemeral images appear. But the darting eye lingers on a handful of indelible events that, more than the others, shaped the character of Alachua County," wrote Bob Arndorfer, *Gainesville Sun* staff writer. Pictured is Waldo activist Mace Wilson.

DRINKING FOUNTAIN

WHITE COLORED

Signs of the time spelled segregation, injustice, inequality, based on the Jim Crow laws. After the Civil War, most Southern states passed anti-black legislation, including laws that discriminated against blacks and focused mainly on public uses.

"Fight for Freedom" was a slogan adopted by the NAACP and a diverse group of courageous men and women organizing to fight Jim Crow laws.

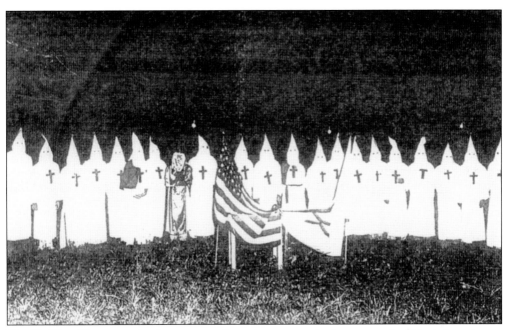

The Ku Klux Klan organized to protest the autonomy and advancement of black Americans. And still we rise, in spite of a 500-year deficit.

This is a 1912 photograph of the lynching in the Gainesville courthouse square of two Archerians, father and son Cain and Fortune Perry. Deputy Slaughter and F. V. White were summoned to Archer to quell a disturbance already under control. They arrived with guns drawn using epithet and threats, which resulted in the deaths of both officers. The two most feared Archerians present paid by hanging. Alachua County lynchings between 1882 and 1937 total 23, and Florida lynchings during same period total 236, more than any other county and state in the United States. Those hanged in Alachua County were Tom Complon (February 17, 1891); Champion (February 18, 1891); Andy Ford (August 25, 1891); Henry Hinson (January 12,1892); Unnamed Negro (September 6, 1892); Charles Wiley (January 12, 1894); William Rawls (April 2, 1895); Harry Jordan (January 13, 1896); Alfred Daniels (November 26, 1896); Manny Price and Robert Scruggs (September 1, 1902); Jumbo Clark (January 14, 1901); Cain Perry and Fortune Perry (September 27, 1912); John Haskins, Jim Dennis, Stella Young, Mary Dennis, Bert Dennis, Andrew McHenry, and Josh Baskin (August 19, 1916); Abraham Wilson (January 17, 1923); and George Buddington (December 27, 1926).

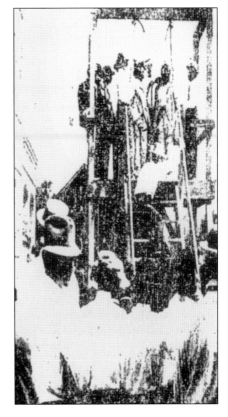

A diverse group founded the NAACP on February 12, 1909. W. E. B. DuBois (black male), Ida Wells-Barnett (black female), Henry Moscowitz (Jewish male), Mary White Ovington (white female), Oswald Garrison Villard (German-born white male), and William English Walling (white male) were among the founding members. Alachua County NAACP continues their legacy and aims to eliminate the remaining barriers to freedom and equality for all Americans. Michael Bowie is the current president, and Evelyn Foxx is vice president.

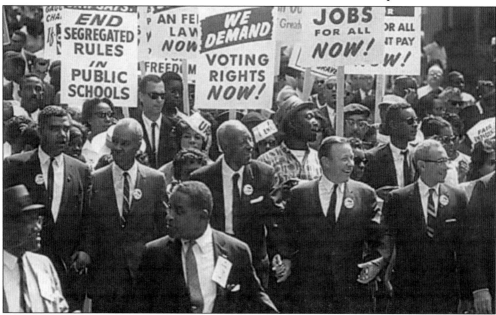

Black Men of Worth neighborhood organizations developed defensive practices of protection. Light-skinned male African Americans infiltrated the KKK, becoming informants keeping abreast of the organization's movements. To enter the privacy of the KKK, one only needed to use the "N" word—the racial-slur password. Long before the civil rights movement, the Men of Worth fought for equal rights.

Lucius Palmore Sr. was a High Springs fireman in the early 1900s. In 1925, he purchased a new Ford and painted his house. It is believed that Palmore was killed by a militant group while returning home from Jacksonville in September 1925. A white undertaker picked up his body, thinking he was a white man. Four other siblings lost a father, including educator Ceola Palmore Watkins. May Etta Cook Palmore raised all five children alone.

Clyde Watkins Jr. banked on justice taking intellect to the next level to demonstrate that the loss of family does not limit dreams. His grandfather Lucius Palmore Sr. was denied equal opportunity and killed for wanting his family to live comfortably. Daughter Ceola Palmore Watkins never saw her father because of that untimely tragedy that occurred the same year she was born. Her son, Clyde, grew up to become a practicing medical doctor.

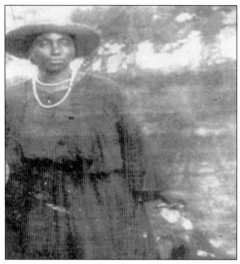

Juliann Sams, once enslaved, was a bearer of hope, changing her name from Julia to Juliann when she was freed. She changed her daughter's name from Maria to Mariah and lived to witness her granddaughter, Mahulda, change her name several times. Elbert Baughman, Mariah's father, rode shotgun with James M. Parchman's kidnap-and-forced-removal posse.

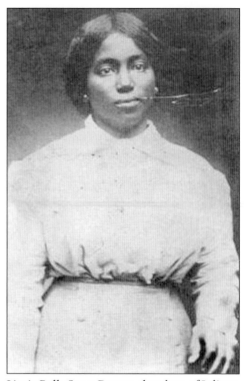

Lizzie Polly Sams Brown, daughter of Juliann Sams, sports a wig in this 1921 photograph. She never felt safe living by SR 27. She was a seamstress, a church soloist, homemaker, and mother of 10. Being married to Charlie L. Brown, an activist, was a full-time job. He passed as white when it was necessary and invaded the KKK as an informant. His daughter Theresa Brown Robinson described her father candidly, "Papa was something else, a force to reckon with!"

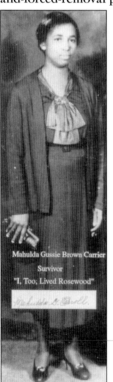

Mahulda Gussie Brown Carrier
Survivor
"I, Too, Lived Rosewood"

Mahulda Gussie Brown Carrier, granddaughter of Juliann Sams and daughter of Lizzie Sams Brown, lived a rugged life. She, too, changed her name several times. Carrier is believed to be the second black female principal in the state of Florida and the first and only black female principal in Levy County until February 28, 2007. A sample of her penmanship is at the bottom of this photograph.

This letter from 1941 validates that Mahulda Gussie Brown Carrier lived at 520 West Court Street in Gainesville and was married to Aaron Carrier. It did not matter how often she changed her name and moved; the post-office informants kept her files out front, stalking her and reporting her every move, she concluded. Family documents indicate that she ended her own life to escape.

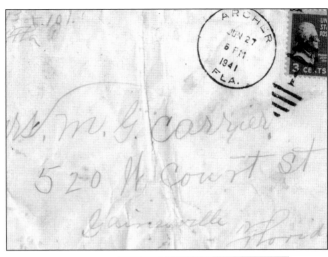

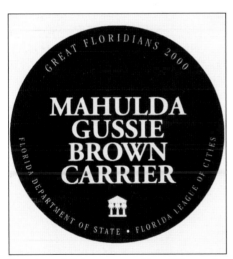

In spite of living most of her life on the edge, Mahulda Gussie Brown Carrier received the ultimate honor when the Florida Department of State and the Florida League of Cities recognized her priceless and worthy contributions and awarded her the "Great Floridian 2000" plaque, which was initiated by her niece Lizzie Jenkins to preserve her aunt's real name in Alachua County's history. Carrier, a philanthropic force, was one of 2,000 unassuming Floridians recognized in the year 2000.

History repeats itself in the Sam Brown Carrier family. In 1941, Mahulda Gussie Brown Carrier and her husband, Aaron Carrier, changed their last name to Carroll and lived at 520 West Court Street in Gainesville, Florida. Mahulda changed her first name to Hulda. She as a teacher and her husband as a cross-tie cutter went underground because of their Rosewood experiences. She taught part-time functional reading and math to male students at the University of Florida in a basement. She was required to dress as a maintenance worker. She was paid in cash in exchange for a contract to become principal.

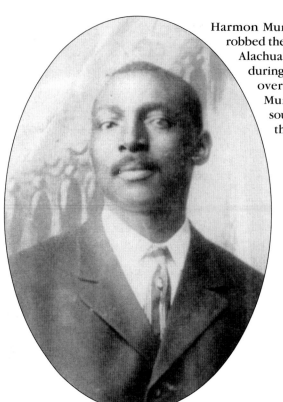

Harmon Murray, in the likeness of "Robin Hood," robbed the rich and gave to the hungry throughout Alachua County. Merchants feared for their lives during unpleasant food raids, willingly handing over items requested without hesitation. Murray's horse, Mandy, made a snorting sound, day and night, upon arrival to deliver the acquired goods. He died naturally.

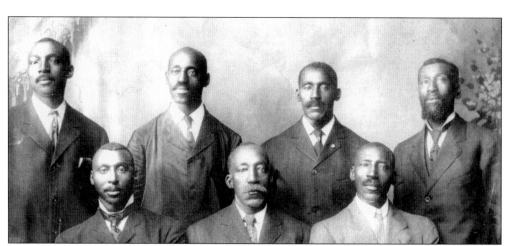

Alachua County Men of Worth, the Knights of Pythias, and the Night Riders established a local chapter in Archer, which became the mecca for recruiting other Alachua County men who willingly worked all four corners of Alachua County without hesitation, protecting family members and property perimeters. Groups of this sort organized throughout America, resisting insurgents and blocking conflict by any means necessary. Pictured from left to right are (first row) Hampton Williams, Charlie L. Brown, Abram Carnes; (second row) Harmon Murray, Hamp Stafford, Brady Sams, and James Blue.

Before the civil rights movement, inherent beauty did not guarantee beauty queen Afronia Johnson and her daughters an entry in the Silver Springs beautiful competition. Therefore, black contestants could only participate in the Paradise Park Beauty Contest. The three Johnsons won the beauty crown at different intervals.

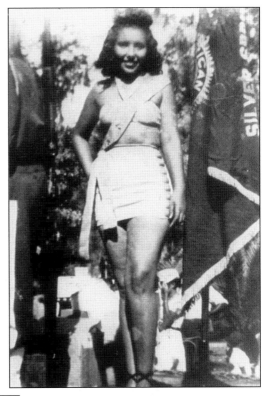

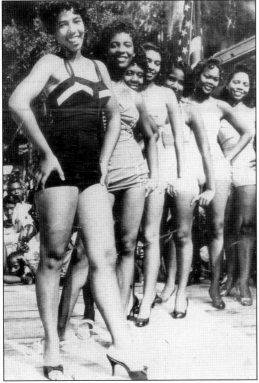

Sisters Carrier Johnson Parker-Warren and Gloria Johnson Pasteur took beauty to the next level, following in the footprints of their mother, Afronia Johnson. Both sisters were crowned "most beautiful" at Paradise Park.

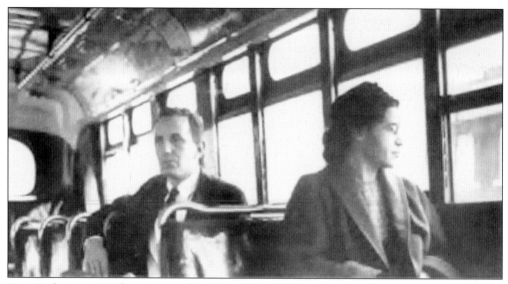

Rosa Parks, a national treasure, refused to relinquish her seat to a white man on a city bus in Montgomery, Alabama, in 1955. This act of courage was a seminal event that helped shape the civil rights movement of the 1950s and 1960s. In October 2006, Highway 301, which runs through Alachua County from Waldo to the Marion County line, became "The Rosa Parks Memorial Highway."

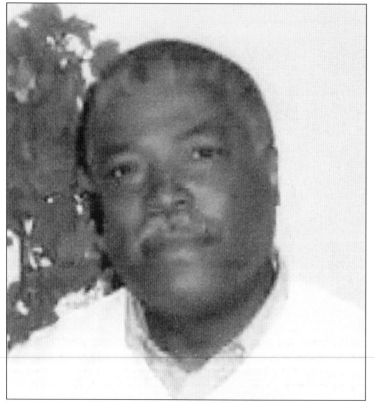

Joel Buchanan was one of three black students attending Gainesville High School in 1964 and who resisted injustices. Buchanan is the African American history liaison for the University of Florida Smathers library and is considered to be Gainesville's resident expert on local African American history. Buchanan started recording oral black history in Gainesville in the mid-1980s.

In 1970, educator Julia Hale Harper was the first African American teacher to challenge the racial divide during the 1960s and 1970s at University of Florida P. K. Yonge Laboratory School. Harper, a kindergarten teacher, proved that teachers effect learning based on application and approach.

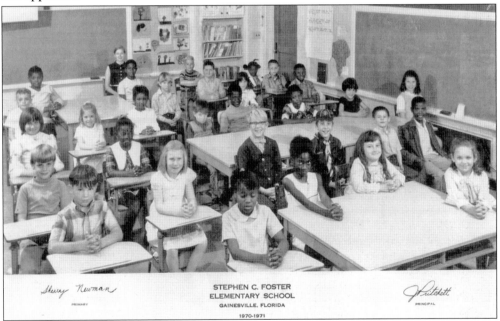

Sherry Newman
PRIMARY

STEPHEN C. FOSTER
ELEMENTARY SCHOOL
GAINESVILLE, FLORIDA
1970-1971

Pritchett
PRINCIPAL

In 1970–1971, principal Jim Pritchett balanced the racial divide, joining many other schools in Alachua County and breaking down the barriers of segregation at historic Stephen C. Foster Elementary School. His philosophy focused on the importance of teaching the whole child, challenging individual differences. Sherry Newman, a teacher, made children's dreams a reality.

Jesse James Aaron, a self-taught carver deep in his 80s, had an early-morning premonition to go out and carve. Jesus brought the message to him to pay for his wife's cataract surgery. He sent all of his children through college before he started this art.

Atkins Warren, Gainesville's first and only black chief of police has received various awards throughout his career in law enforcement. Warren, who still lives in Gainesville, remains active in the community. Warren said it was one thing that he had in his arsenal that none of the others had in theirs. "I offered something that they probably hadn't seen before, being a black guy," Warren said. "Gainesville was experiencing tough times as a result of shootings and tensions between residents and the police department. My rationale for seeking the position was different than most. I dealt directly with problem situations when I was in St. Louis. I had spent 32 years in the St. Louis Police Department, and it was no problem I could not handle. Name it, and I could handle it."

Tom Coward served as a teacher, administrator, and district supervisor for the public-school system of Alachua County. He also served on the Alachua County Board of Commissioners for four terms, which were four years long. During the civil rights movement, he served on the first biracial committee appointed by the Gainesville mayor. He is a Gainesville native and is married to Dona H. Coward. They are the parents of Marva O. Coward.

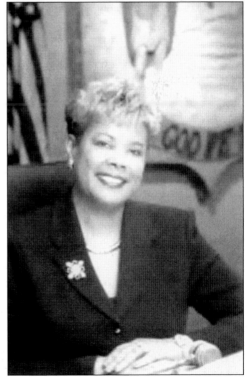

Commissioner Cynthia Moore is working toward fulfilling her goals of public service. In 1989, she was elected as the first African American female county commissioner/ mayor. Working hard to serve the community and her constituents brought about her election to the Florida House of Representatives in 1990, where she served for 10 years. Chestnut was the first female African American elected to this seat.

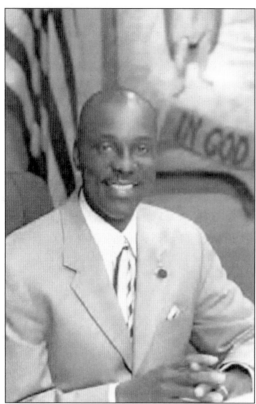

Commissioner Rodney J. Long is the first black official to have held seats in both city and county commissions. He is founder and president of the Martin Luther King Jr. Commission of Florida, Inc., organized in 1982. Jackie Hart-Williams is the founding executive director.

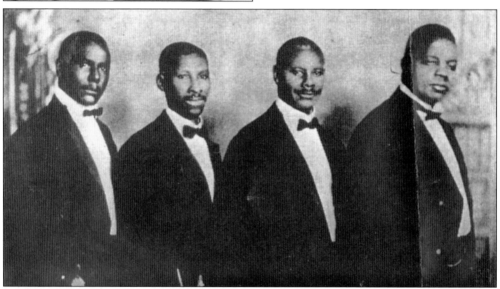

The High Speed Quartette organized in Gainesville around 1914, entertaining audiences with their smooth, well-blended voices in churches, hotels, and clubs throughout the state of Florida. The name High Speed was based on the speed of the Ford automobile they drove to reach their shows. All of them sang in their church choirs for more than 50 years. Their style leaned toward spiritual and comical songs. Pictured from left to right are James Smith, Oscar Perry, Virgil Smith Sr., and Lonnie Brown.

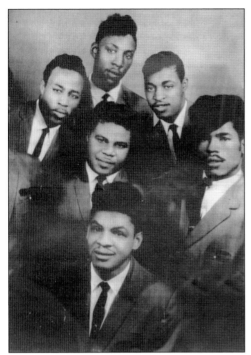

The "conk" worn by this group of gospel singers was a popular hairstyle for African American men from the 1920s to the 1960s. The process required chemicals to straighten the hair. Some African Americans of Caucasian descent (white father, black mother) chose to simply slick their straightened hair back and allow it to lie flat on their heads.

Liz Jenkins sports an Afro, which gained popularity during the 1960s and 1970s in connection with the growth of the Black Pride and Black Power political movements and with the emergence of "blaxsplotation" films and disco music. Among blacks, Afros were a proclamation of "Black is Beautiful!" a popular slogan of the time. The Afro became a symbol of race, pride, and progress.

Mattie Newton, of Long Pond, grandmother of Audrey Newton Crawford, sports the traditional "African braid," also known as the "African underbraid" or "cornrow," which is a noted African hairstyle worn by African queens and princesses.

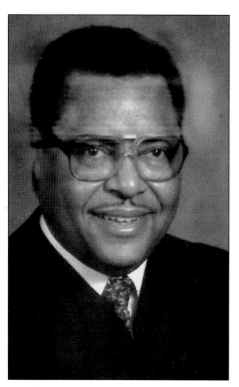

Judge Stephan Mickle was the first African American to earn a degree from a UF undergraduate program (political science in 1965). The Gainesville-raised Mickle got a master's in education (1966) and then became the second African American to graduate from Florida's law school (1970). He was the first black lawyer to practice in Alachua County and to be appointed both county judge (1979) and 8th Judicial Circuit judge (1984). In 1992, he became the first Gainesvillian to sit on Tallahassee's First District Court of Appeals. In 1997, Sen. Bob Graham recommended him for a federal judgeship in Florida's Northern District, and, in 1998, after sailing through mandatory attorney general and FBI investigations, Mickle was officially nominated for the position by Pres. Bill Clinton. University president John Lombardi honored Mickle as a distinguished alumnus of the University of Florida. Lombardi declared that "through his accomplishments and service," Judge Mickle had brought "honor and prestige" to his alma mater.

In the 1870 Alachua County Census, a Joseph Valentine is listed as a resident of Gainesville, age 26, black, and literate. This moment in the life of Joseph Valentine comes from the pages of Alachua County Judgment Book B in the Circuit Court for the Suwannee Circuit Alachua County Fall Term 1862. "Then came a free Man of Color aged about 22 years by Andrew Robb Judge of Probate for said County, who declared that he desires to sell himself to Philip Dell as a slave, and desires the Court to Examine him whether the act is done of his free will and accord or not Andrew Robb Judge of Probate of said County. Whereupon the Court ordered the said Joseph Valentine to be brought before it and appointed E. M. Graham Solicitor to represent said Negro, and the said Joseph Valentine Negro as aforesaid having been brought into Court and Examined, as to whether the act of selling himself to Philip Dell was voluntarily or not declared that he did so without fear or compulsion and of his free will."

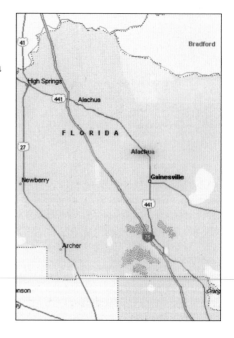

Six

JOBS
Multiple Choices

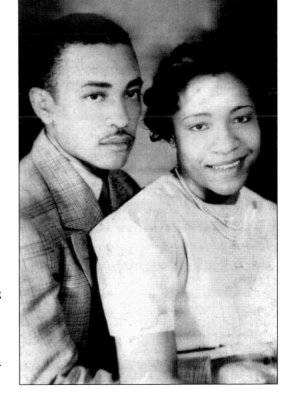

Richard and Mary Foster Brown
married March 4, 1939, and lived
in Detroit. In 1943, at age 26, Mary
worked her first job, as a riveter putting
clamps in airplane wings. The U.S.
entry into World War II created an
unparalleled demand for new riveters.
It was the first time in history that
black women obtained entry into major
industrial plants.

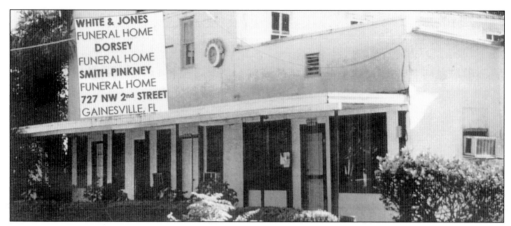

Three generations of funeral-home directors operated out of same building. Around 1919, this building was home to a restaurant, a barbershop, a beauty salon, and a Central Insurance Company office. In 1932, Rev. D. E. White and Azzie Jones, his brother, purchased the building and launched White and Jones Funeral Home. Arnold D. Dorsey started working as a funeral director's attendant in Tallahassee when he was 15 years old. Dorsey moved to Gainesville and joined the White and Jones firm in 1961, purchasing the business when White retired in 1964, and continuing the legacy for about 40 years. Fairbanks resident George Pinkney Jr. married his high school sweetheart and moved to Gainesville, making his home on Second Street on the second floor above White and Jones Funeral Home. Inspired by the funeral business, Pinkney Jr. enrolled in college, earning a degree in mortuary science. He established his first funeral home in Hawthorne in 1973. George Pinkney III was born a year later at Alachua General Hospital and raised in the apartment above the funeral home. The Pinkneys recently returned to where they started out to open a second funeral home business: Pinkney and Smith Funeral Home at 727 Northwest Second Street. History has its way of repeating.

George Pinkney Sr., George Pinkney Jr., George Pinkney III, George Pinkney IV, and George Pinkney V are living testimony that strong parenting skills with unbroken circles yield productive, strong African American men. The Pinkney family of Fairbanks is a prime example of how communities are developed and sustained. Pictured from left to right, Lizzie Mae Pinkney, Onealy Pinkney Cash, and Queenie Pinkney Clark made certain the Pinkney home-taught rules were unbroken.

Rev. D. E. White was also a schoolteacher, a railway mail carrier, and pastor of Friendship Baptist Church from 1939 until his death in 1968.

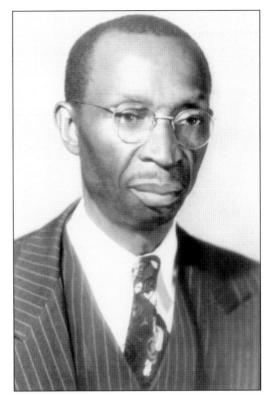

Susie Mae White was a teacher, a psychologist, and counselor for Alachua County Schools. She co-owned White and Jones Funeral Home, and retains the funeral home today though well into her 90s. She is an author of two books and a graduate of Florida Memorial University in Miami, Florida.

A historic barbershop establishment was once owned by Reverend Williams and Junior Johnson. In the late 1920s, Willie Plummer founded Plummer's Barber Shop, which opened many years before his son Charles Plummer and grandson Cleve Sharpe joined the team. Pictured here, Clevern continues the Plummer legacy.

In November 1992, Barbara Sharpe was the first black female elected to the Alachua County School Board since Reconstruction. She is also the first board member in the state to become a state-certified board member after just one year in office. Sharpe was elected president of the Florida Schools' Boards Association, inclusive of all 67 counties in the state of Florida in 2001.

Barbara Higgins was a lifelong resident of Gainesville involved in civic and community activities. She attended public schools in Alachua County and studied at Bethune Cookman College graduating in business administration. She was the first black employee and deputy director for approximately 30 years.

Odetta MacLeish-White is a past president of the League of Women Voters of Alachua County/Gainesville, and the first African American president to serve in that capacity (2002–2004). She received the 2006 Ida B. Wells Award from the Gainesville Commission on the Status of Women during the Women's History Month awards reception.

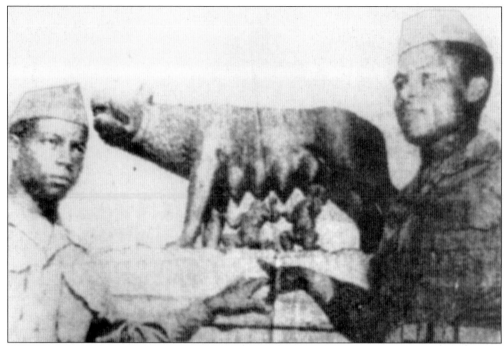

The capture of Rome provided these two 5th Army twins with a unique opportunity to see this famous statue of mythical twins suckling from a she-wolf. This is no ordinary occasion for the Kyler twins, who hail from Archer, Florida. The sculpted mythical twins are, of course, Romulus and Remus, who founded the Eternal City. When the Kyler twins were born 22 years ago, their parents named them Roamules and Reamuless Kyler, after the twins of Rome. Their trip overseas in the U.S. Army afforded these twins an opportunity to see the statue of their famous namesakes, and they enjoyed the meeting. Roamules, at left, is a sergeant, while Reamuless is a staff sergeant.

During World War II, 2nd Lt. Marvin Engle of Waldo served in the U.S. Army.

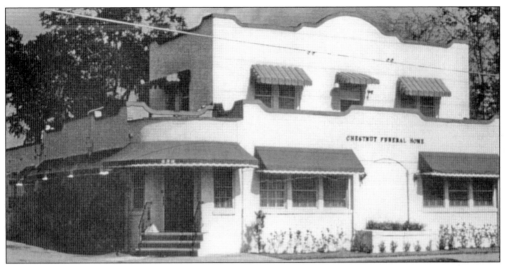

Chestnut Funeral Home, shown in this 1989 photograph, is one of Gainesville's oldest funeral homes. In 1914, Matthew E. Hughes and Charles Chestnut Sr. founded Hughes and Chestnut Funeral Home in Ocala, Florida. Chestnut is the father of Gloria Chestnut Duncan and of Charles Chestnut Jr. Continuing the business is Charles Chestnut III, Charles Chestnut IV, and Charles Chestnut V. (Courtesy of the Pleasant Street Historic Society.)

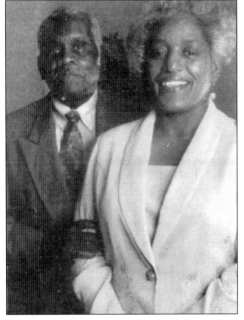

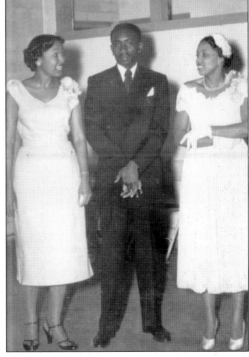

Joseph and Oretta Williams Duncan and Collin and Gloria Chestnut Duncan established Duncan Brothers Funeral Home in 1953, located on historic Seminary Lane. Pictured here, Collin and daughter Iris Duncan continue the funeral-home legacy more than 50 years later. (Courtesy of the *Gainesville Sun*.)

Pictured left and center, Oretta and Joseph Williams Duncan married more than 40 years ago, and they are co-owners of Duncan Brothers Funeral Home. Nadine Jones, on the right, was one of their bridesmaids.

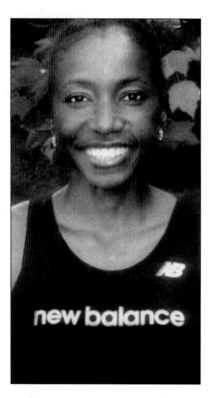

Jearl Miles Clark was a five-time Olympian, in 1988, 1992, 1996, 2000, and 2004. She is one of America's greatest track and field athletes. As a five-time Olympian, Clark has an excellent story to tell. She has done motivational talks and several track clinics. She is the daughter of Aaron Davis Miles and Eartha Miles Hutchinson.

Joe Louis Clark, former U.S. Army drill instructor, sees education as a mission. He worked while attending high school to support his mother and siblings. He then went on to get his B.A. from William Paterson College and a master's degree from Seton Hall University. Clark held high expectations for students, challenging them to develop habits for success and confronting them when they failed to perform. On a single day at Eastside, he expelled 300 students for fighting, vandalism, drug possession, profanity, or abusing teachers. He explains, "If there is no discipline, there is anarchy." Clark was the subject of the Warner Brothers film *Lean On Me*, starring two-time Oscar nominee Morgan Freeman as Joe Clark. Clark himself was named one of the nation's 10 "Principals of Leadership" in 1986. Clark, an Alachua County resident, lives in Gainesville with his wife, Gloria, and owns a Newberry farm. He is the father-in-law of Jearl Miles Clark and father of three successful children, Joetta, Hazel, and J. J.

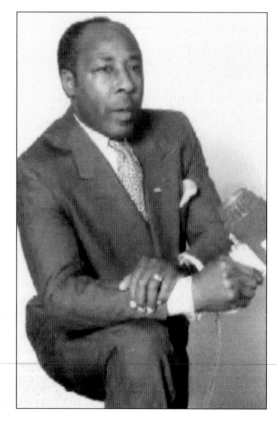

Doris Williams Jones, was Archer's first and only African American female assistant principal at Archer Community School. She was a high school physical-education and science teacher and an elementary schoolteacher before being promoted to assistant principal. She married Arthur Jones, and they have four children.

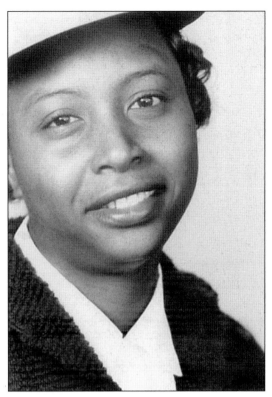

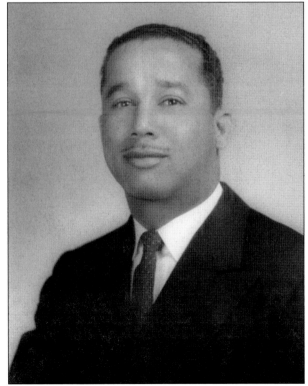

Arthur Jones is a veteran who served more than 20 years in the army. A resident of Alachua County, he married Doris Williams Jones.

Army officer Wilbur McKnight, a World War II veteran, served his country without hesitation. He was married to Thelma Burnette McKnight, and their six children continue their Gainesville legacy.

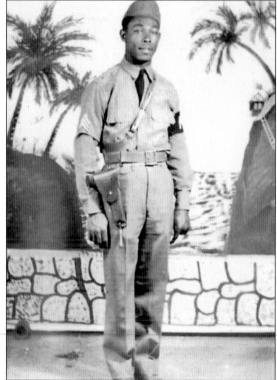

Willie Laidler, a Waldo entrepreneur, owned a cleaning business after serving his country in World War II. He was married to Waldo's registered nurse and historian Mabel Vernon.

Prince Isaac, a Waldo resident, was committed to serving the United States, a country he loved and represented with honor. International exposure and opportunity proved rewarding, but bigotry and disrespect followed him abroad as he fought for America.

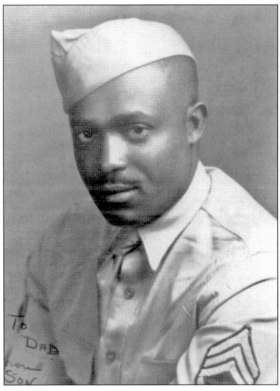

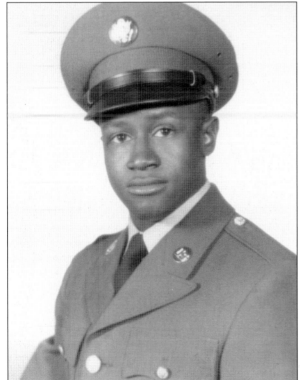

Charles Gaddy, a Grove Park resident, enlisted in the army at age 18. He served his time and was honorably discharged. He was able to travel places he never would have visited otherwise.

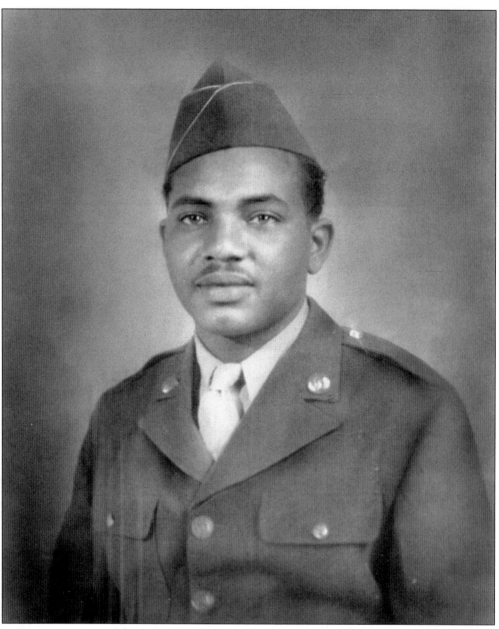

Arthur Vernon, son of George and Pearl Shaw Vernon, served his country proudly. His Waldo family and friends were proud to see men go off to the serve their country. Pride radiated throughout the small communities. Every soldier found enough money from his monthly check to send home to supplement parents' low wages.

Seven

ORGANIZATIONS
Charitable Giving

Zeta Phi Beta Sorority was founded
January 16, 1920, at Howard University
in Washington, D.C. The "Five Pearls"
created the sorority to address concerns
in the African American community. It
was founded on the principles of finer
womanhood, scholarship, sisterhood,
and service. In 1972, Zeta initiated a
partnership with the March of Dimes to
encourage expectant mothers to seek
prenatal care within the first trimester
of pregnancy. Nationwide, Zeta has over
175 Stork's Nests, and 28,000 women
were served in 2005. Pictured from left to
right, the founders were Arizona Cleaver,
Fannie Pettie, Myrtle Tyler, Pearl Neal,
and Viola Tyler. Alena Lawson is president
of the local chapter, and Lizzie Jenkins
is vice president. The sorority actively
provides scholarships in Alachua County.

Phi Beta Sigma Fraternity was founded in 1914 at Howard University by A. L. Taylor, Leonard F. Morse, and Charles I. Brown, with the concept, "Culture for Service and Service to Humanity." James Weldon Johnson, nationally known composer of "Lift Ev'ry Voice and Sing," is a member of this fraternity. Phi Beta Sigma Fraternity and Zeta Phi Beta Sorority are the only constitution-bound African American fraternity and sorority. Darry Lloyd is president of the local chapter, and Rory Jones is vice president.

On September 19, 1963, at Morgan State University, 12 students founded Iota Phi Theta Fraternity, Inc.

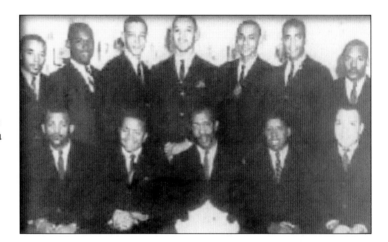

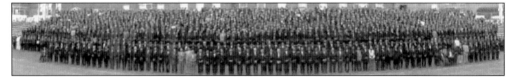

This is the 2006 centennial photograph taken at Howard University to celebrate 100 years of leadership and service. The Alpha Phi Alpha Fraternity was founded in 1906 at Cornell University as the first Negro Greek-letter organization. Darrell Johnson is president of the local chapter, and Marvin Ivey is vice president. (Photograph by Jeff Lewis.)

94

Sigma Gamma Rho Sorority was founded in 1922 at Butler University. The objectives are to exemplify sisterhood, encourage community service, and provide scholarship to graduating seniors. Luella Johnson is president of the local chapter.

Alpha Kappa Alpha Sorority was founded in 1908 at Howard University. Ethel Hedgeman Lyle saw the crystallization of an idea for a unique organization at Howard University that would cause higher ideals of womanhood to be implemented in the hearts of black women and girls in America. Yvonne Rawls is president of the local chapter, and Florida Bridgewater-Alford is vice president.

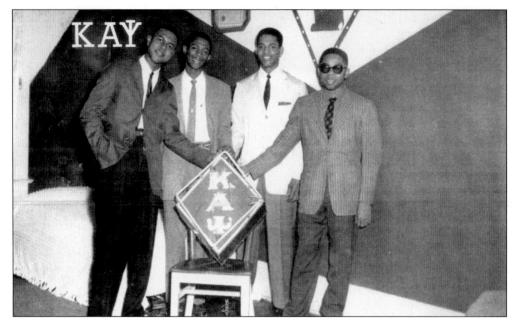

Kappa Alpha Psi Fraternity was founded in 1911 at Indiana University to share a vision communicated by founders Rev. Elder Watson Diggs, John Milton Lee, and Buron Armstrong. The prudence of these men inspired them on January 5, 1911, on the campus of Indiana University, to sow seeds for a fraternal organization. Sam Byrd is president of the local chapter.

Delta Sigma Theta Sorority was founded at Howard University in 1913, aiming to be something more serious than a social activity. They developed a union of college women based on certain cardinal principles and pledged to uphold lofty ideals. Jancie Vinson is president of the local chapter, and Diane McPherson is vice president.

Three Howard University undergraduate students, Edgar A. Love, Oscar J. Cooper, and Frank Coleman, with the assistance of their faculty adviser, created the Omega Psi Phi Fraternity on November 17, 1911. "Manhood, scholarship, perseverance and uplift" were adopted as cardinal principles. Marion Chisholm is president of the local chapter.

The Female Protective Society, Inc., was founded by Chief Matilda Haile in 1903 to assist women in need. A resident of Jonesville, she met with a group of willing workers to begin the first initiative. The fifth chief, Theresa Brown Robinson, reigned for 10 years and championed the construction of its existing building. Beatrice Certain is chief, and Rosa Rutledge is vice chief.

Charles Goston has been the publisher and owner of *Black College Monthly* and *The Voter's Guide* for 18 years. He is also the president of the Alachua Democratic Black Caucus, which serves all Democrats. The membership focuses on neighborhoods where voter turnout is low. Rosemary Christy is vice president.

The distinguished Archer Night Riders, Knights of Pythias, and Men of Worth alliance worked to enhance and empower community relations. They addressed each other as "Sir" and built lasting relationships. It was imperative for them to take care of their own. The Archer Night Riders, a local affiliate of a bigger Alachua County organization, patrolled property perimeters on horseback. Rev. Charlie L. Brown, audit chair of the Masonic Chapter writes, "We, your auditing committee, beg to make our report as follows for this semi annual term."

The Knights of Pythias and Calanthes (females) 1918 emblem encases Addison Brown, Sr. Their purpose was to improve the living conditions in each community. They led the struggle to combat racism, protecting family, home, and property.

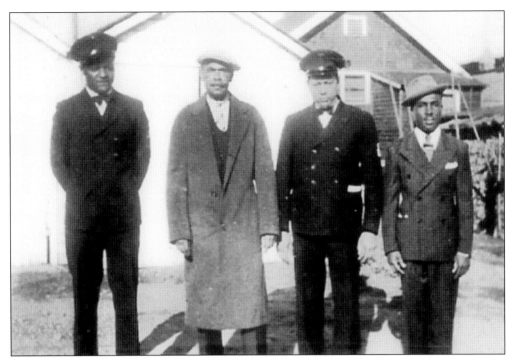

Waldo Men of Worth organized a Masonic chapter to serve their small community. Meetings were held at neighborhood churches to set guidelines.

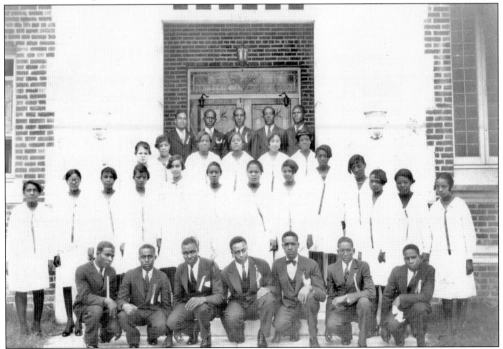

Annual conventions held by local Masons and Eastern Stars represent an important part of the self-help movement. Black fraternal organizations, churches, and schools were important support systems during this time period.

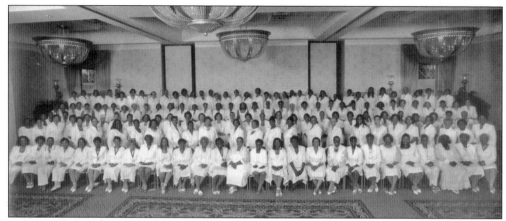

October 27, 2006, indeed was a historic day for The Charmettes, Inc., in Washington, D.C., with the dedication of the Gwendolyn Baker Rodgers Chemotherapy Infusion Suite at the Howard University Cancer Research Center. Founded in West Palm Beach County, Florida, in 1951, the organization has donated more than $250,000 to Howard University Cancer Research Center. Alachua County national officers are Lizzie R. Jenkins (national secretary) and Bettye G. Jennings (immediate past national president). Victoria Ellis is national president.

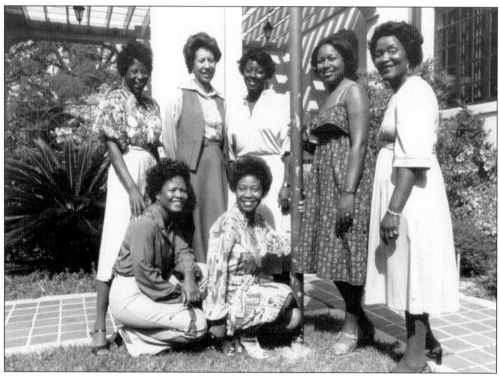

Charmettes, Inc., was founded locally in 1975, focusing on cancer research and scholarship. Pictured from left to right are (first row, kneeling) Doris Willis and Ann Nelson; (second row) Janie Williams, Barbara Smith, Cynthia Cook, Rosemarie Turk, and Ellen Rush. Ora White is president, and Gerie Crawford is vice president.

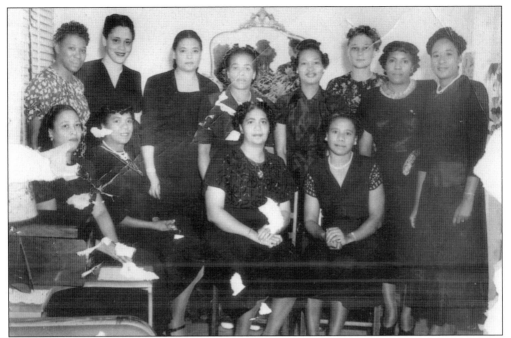

Excelsior Matrons, Inc., organized to serve Alachua County. Pictured from left to right are (first row) Ruth Kendall, Mattie Hendley, Marie Adams, and Jessie West; (second row) Thelma Jordan, Della Jones, Altamese Cook, Fannie Goodman, Thelma Glover Welch, Ida Anderson, Mildred Green, and Carrie Lovett. Carrie J. Parker-Warren is president, and C. Ann Scott is vice president.

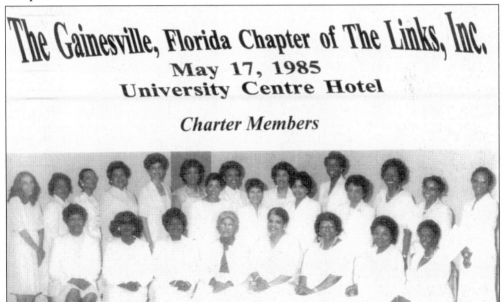

Founded in 1946 in Philadelphia, Pennsylvania, The Links, Inc., is an organization of over 10,000 African American women. The Gainesville chapter organized in 1978 and is dedicated to improving the physical, emotional, intellectual, and moral status of African American women.

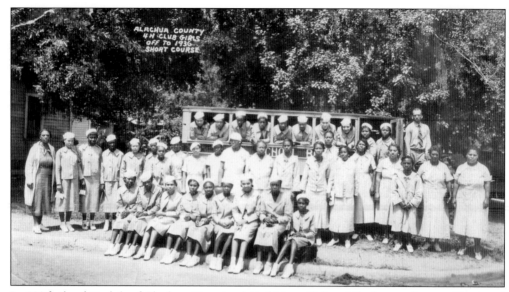

In 1936, the 4-H club of Alachua County visited Mary McLeod Bethune, the president and founder of Bethune Cookman College, in Daytona Beach, Florida. Mary McKenzie and Frank Pender taught 4-H club members how to build a safe open fire, quilting techniques, gardening, and the proper way to can vegetables in jars by adding a teaspoon of salt to each jar. Collins Duncan was the workshop presenter for the boys, and Mabel Vernon was the workshop presenter for the girls.

Archer Community Access Center is a comprehensive community-change initiative that uses community-based technology centers as a catalyst and adds other program activities as the organization matures. An affiliate of the Community Technology Center Network, ACAC is able to access administrative and technical support through an association of over 1,000 community technology centers located throughout the country. Carolyn Khalfani is president, and Akil Khalfani is vice president.

The congregation of New Hope United Methodist in Hawthorne registered a significant moment in African American history when they donated their long-standing church building to house Hawthorne's Historical Museum and Cultural Center. The building was constructed in 1907 and was moved from its present location on April 17, 1997. The museum opened its doors to the public on Johnson Street in 2002.

The Real Rosewood Foundation, Inc., preserves the legacy of the horrific 1923 massacre, wherein a mob killed five blacks, lynched one, and burned down the town. At the request of Lizzie Jenkins, president and founder, on May 4, 2004, Gov. Jeb Bush dedicated a historical marker in memory of those who lost their lives and property. The marker is cosponsored by the State of Florida Historic Department and The Real Rosewood Foundation, Inc.

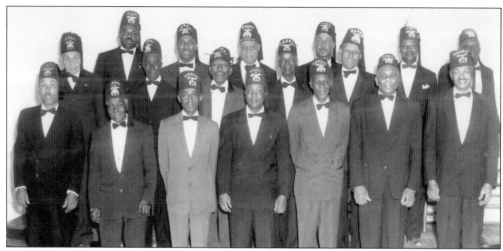

Rochelle's Men of Worth and Masonic group met monthly to discuss business ventures. Most civic organizations were established to assist community goals and to provide scholarships for local high school graduates.

John Braker was an outdoorsman attracted to hunting and fishing at an early age. He caught, trapped, and killed enough to supply his family and neighbors. Back then, blacks looked out for each other and took care of their own. Braker was affiliated with the Rochelle Masonic chapter.

Bly's School of Cosmetology trains students to become professional cosmetologists, manicurists, and barbers. It provides competency-based academic programs, which measure acquisition of knowledge and skills. The school's curriculum was developed based on its mission to adequately prepare students to take and pass the state board examination and help them master the skills to enhance their opportunity for entry-level employment. Leonard R. Kearse is the administrator.

Eight

HEALTH AWARENESS
Care Givers

Mittie Clayton, a well-known Archer midwife who
accepted goods for service, was always at the disposal
of her clients. If families could not afford to pay, she
served them anyway. Clients sometimes lived far apart
on large farms, so she kept a packed bag and stayed a
few days after the birth of a child in the event a doctor
had to be summoned. Neighborhood networks tracked
Clayton's whereabouts in the event she was needed for
another delivery while still out in the field.

Dr. Robert B. Ayer Sr. was born in Bamburg, South Carolina, in 1862. He and his mother, Jane Haygood, and sister Annie Haygood-Gass migrated to Gainesville in the late 1800s. Ayer graduated from Cookman Institute for Boys, a barber school, in Jacksonville, Florida. He was a practicing barber prior to pursuing medicine. He received a medical degree from Meharry Medical College, in Nashville, Tennessee, returning to Gainesville to practice medicine for more than 37 years. He was the first African American to practice medicine in Gainesville, Alachua County, beginning in 1900. Two of Dr. Ayer's sons and two grandchildren perpetuated the family tradition in the practice of medicine. His only living son, Robert B. Ayer Jr., a retired educator, resides in Gainesville.

Ayer's Pleasant Street building was a combination drugstore and office. His early practice consisted of office visits as well as house calls over the entire Alachua County. These house calls were made by horse and buggy until automobiles became available. Ayer was the first African American to own an automobile in Alachua County in the late 1920s.

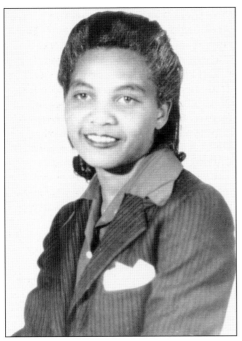

Registered nurse Mabel Vernon was the first black female nurse in Alachua County to graduate from Brewster Hospital.

Florence Albena Keene served dutifully as a nurse and prided herself in assisting patients in Alachua County.

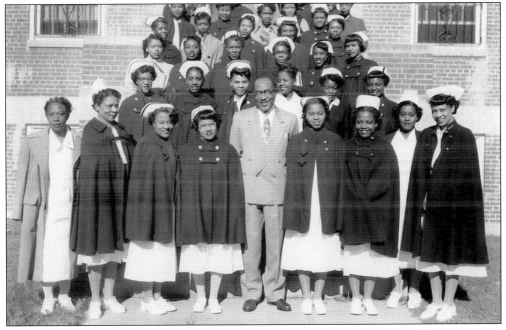

Brewster Hospital educated black nurses in Jacksonville from 1901 to 1966. The hospital was founded because healthcare facilities denied treatment to blacks until the passage of the Civil Rights Act of 1964.

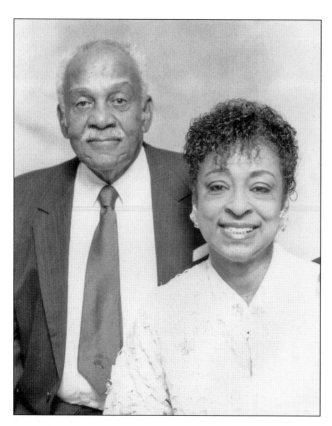

Dr. Cullen Banks practiced medicine in Gainesville for 46 years before retiring in 1996. During the 1950s, Banks became the first black physician to have full privileges in Alachua General Hospital. He was a trustee of North Florida Regional Medical Center and received the 1996 Certificate of Merit Florida Medical Association Award. He was an outstanding physician and the recipient of numerous other awards and credits. He has four children with his wife, Lakay Beasley Banks.

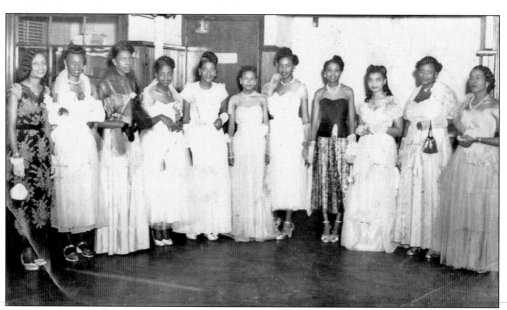

Faced with competition from previously segregated facilities, Brewster Hospital closed in 1966, but not before graduating many nurses from Alachua County. Pictured third from the right is Mabel Vernon.

Dr. Ernest Nelson, M.D., grew up as a small-town boy in rural Windsor. He currently works in Columbus, Georgia.

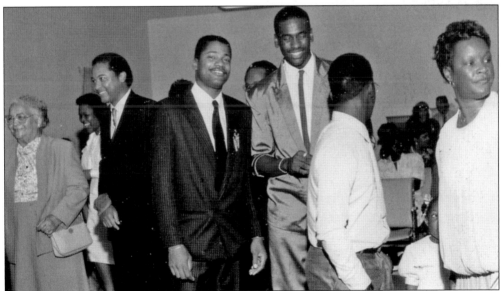

Henry Earl Cotman, M.D., is an oncologist at Bayfront Cancer Care Center in St. Petersburg, Florida. He was the first African American to graduate in medicine from the University of Florida. Cotman grew up on an Archer farm. His parents, Harry and Illinoy Cotman Sr., instilled in him the importance of getting a good education, which resulted in his impressive accomplishments. Pictured from left to right are Illinoy Cotman, Henry Earl Cotman, Terry Wright, Ernest Spann, unidentified, and Henrietta Spann.

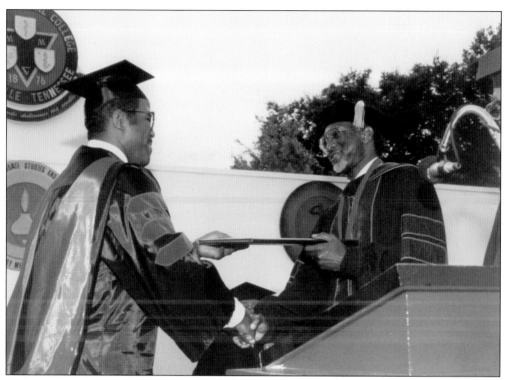

Dr. Clyde Watkins Jr., M.D., grew up in High Springs, was a 1980 honor graduate of Santa Fe High School, and was the son of Clyde and Ceola Palmore Watkins Sr. After graduating cum laude from Morehouse College in Atlanta, Georgia, with departmental honors, Watkins received his medical degree from Meharry Medical College in 1989. Dr. Roderick "Rod" Paige, former U.S. secretary of education, presents this distinguished degree. Watkins completed his internal-medicine residency in 1992 at the Emory School of Medicine. He is board certified in internal medicine at Capstone Medical Group, P.C., in Lithonia, Georgia.

Clyde Watkins Sr., father and mentor of Dr. Clyde Watkins Jr., relished the moment his son advanced from a rural environment to an urban one. Clyde worked at the High Springs train shop and was an entrepreneur.

Nine

FAMILY UNITED
Love, Marriage, Embellishments

Abner McIntyre and Lucy Coleman Cotman McIntyre, both born into slavery in Levy County, in 1862 and 1864, respectively, were married at Alachua County courthouse in Gainesville, on January 24, 1882, exactly 107 years before great-granddaughter Lizzie Polly Robinson Brown Jenkins married. Rev. Major Reddick performed the marriage witnessed by J. A. Carlisle, clerk. The McIntyres had nine children.

John M. Sr. and Lizzie Polly Robinson Brown Jenkins were married on March 4, 1989, at Mt. Carmel Baptist Church with full participation from Lincoln High School classmates of 1957. The event attracted more than 1,000 invited and uninvited guests. Compelled to witness this nontraditional wedding that featured grandmother bridesmaids and grandfather groomsmen were grandchildren, relatives, friends, and coworkers of the bride and groom. The ceremony was dedicated to all ancestors who were prohibited from marrying.

This 1925 photograph commemorates the wedding of Ernest and Idella Bradley Nelson. Idella had grown tired of grueling farm work, so she saved enough money to purchase fabric to make her wedding dress. The couple eloped, and 60 years later they were still in love.

Brothers Marvin and Alphonso Engle pose for the photographer before heading off to Sunday school. Reading, math, and piano lessons were a part of the Sunday school curriculum. Community teachers and educated scholars volunteered free time at church on Sundays. Out-of-town teachers lived in the community.

Richard and Mary Foster Brown celebrate their silver anniversary in this photograph. The map of the Browns' lifetime journey goes from south to north to south again. Now 90 and 92, echoes of love drown out their age.

Pamela Banks waits anxiously for the magical moment to participate in a family wedding ceremony.

Alean Rivers raised six children after her husband died. Photographed with her are children Isaiah Rivers, Elizabeth Rivers Rhodes, and Ora Lee Martin Graham Davis. Not pictured are Willie Rivers, Johnny B. Rivers, and James B. Rivers.

Bernard Lucas, an integral member of the Bradley/Nelson Rochelle family, poses for the photographer.

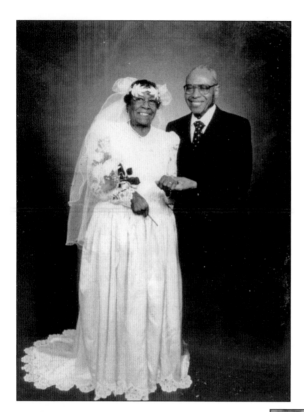

The wedding of William and Alberta Warren Mack took place later in life, making for a chapter's end. The wedding made the local news and is listed in the *Gainesville Sun*'s archives.

Roberta Memory Campbell is currently 101 years of age. She is mother to Clyde Williams, Roberta Betty Lopez, and Mozell Campbell. She is also grandmother to professional basketball player Tony Campbell.

Edward and Ellen Bradley Hall married many years ago, raising their children in a close-knit community setting. Several daughters were college graduates: Fredrica Hall, Mable Hall, and Edith Gill.

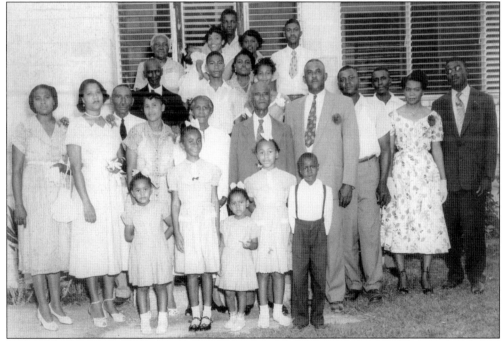

This family photograph is a preservation of Rochelle's family history, when it took a village to raise a child. It still takes a village to raise children.

This is a Lizzie Jenkins look-alike. It is not Jenkins, even though this photograph was found in the family's collection. The dress, magnificently stitched, embodies the style of the era.

"I, Audrey Dixon, am somebody. I am a Dixon and my family loves me. I protect my little brother and my family protects me. Our home is our safety net. Our home reminds me of heaven, home sweet home."

Rev. Burnice Rowe Gaskin lived in Gainesville most of her life. Her parents, Ollie and Katie Rowe, owned a farm in Archer. She moved to Gainesville to attend Union Academy, broadening her educational dream of becoming a minister.

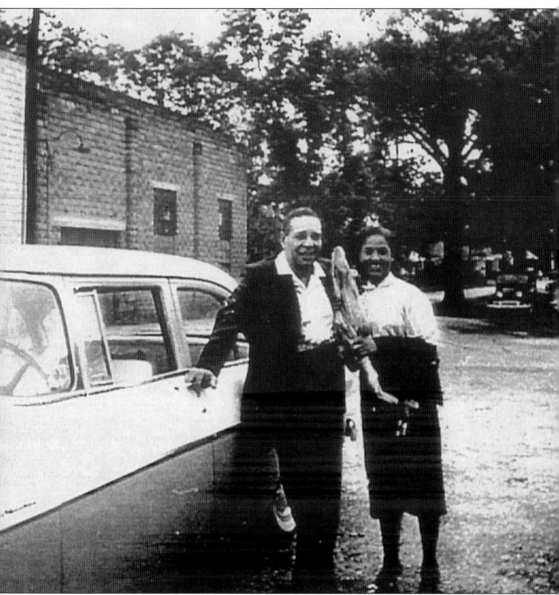

Alphonso and Anna Engle were the perfect couple living among family and friends in the small hamlet of Waldo, where everyone knew everyone.

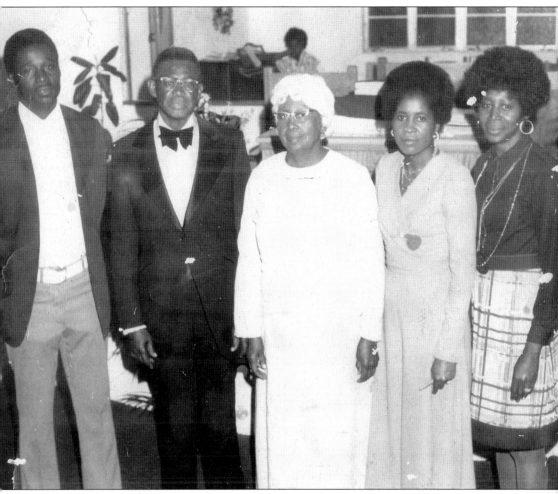

The Robinson farming family lived to remember the Rosewood incident with a sister, a sister-in-law, and an aunt. Mahulda Gussie Brown Carrier, Rosewood's schoolteacher from 1915 to 1923 and Gulf Hammock's principal from 1942 to 1945, spent many hours hiding out on the Robinson farm. Organized by niece Lizzie Jenkins, the Levy County historical marker memorializes Carrier's suffering and triumphs.

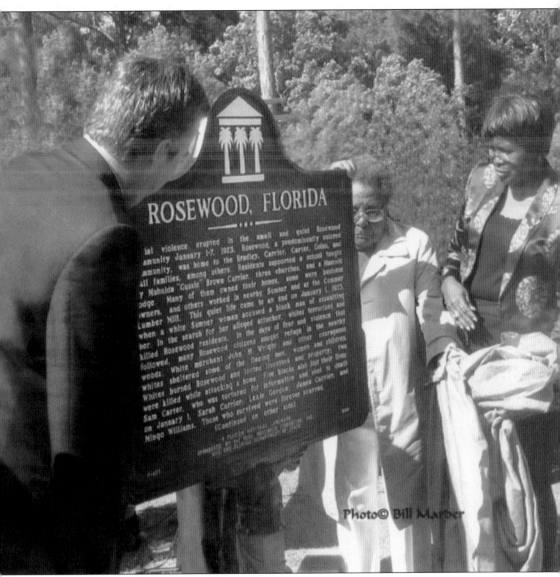

Gov. Jeb Bush was invited to Rosewood to dedicate the marker preserving Rosewood's history. Lizzie Jenkins was honored to introduce the governor on May 4, 2004. Her mother offered the following words of encouragement: "You must show Mahulda's place in Rosewood's history, because she suffered much during and after the massacre and lived to tell me all about it." In the text of the marker, she is credited with being Rosewood's schoolteacher in 1923.

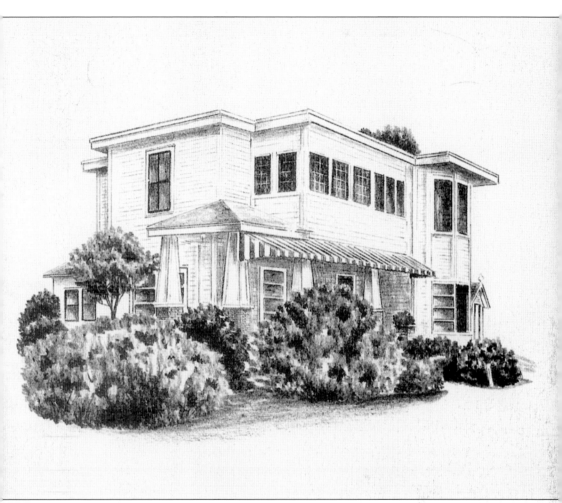

The Hendley home was a safe haven to Dona H. Coward, Earline H. Harper, and Florence H. Williams. Many young people of their age did not have the luxury of growing up as young elites. They remained humble during their young adult years.

In rural Alachua County homes, each household consisted of a two-parent supervisory team and sometimes an elderly grandparent. Most homes had possession of sewing machines, lamps, and woodstoves. Every young girl growing into womanhood was taught to respect the elderly, to sew, cook, clean, wash, and iron. (Courtesy of Carrie Parker-Warren.)

ABOUT THE AUTHOR

Author Lizzie Polly Robinson Brown Bowman Cotman Coleman Davis McIntyre Sams Jenkins's ancestry began maternally in Orangeburg and Bowman, South Carolina. Her great-grandfather, Wesley Brown, a white man, was a slave owner. He left South Carolina, relocating to Florida and bringing with him his enslaved relatives and friends. When they were confronted by outlaws during his travel to Florida, Brown protected them by any means necessary.

On the paternal side, Jenkins's great-great-grandfather, Henry McIntyre, was born in South Carolina, in 1844, and brought to Cedar Key, Levy County, Florida around 1845. McIntyre was a "stockman" (stud) of sorts, a breeder assigned to impregnate women to increase the population, building the economy.

If a child was born with dark skin, he or she was placed with a black family to be raised, and if the baby was born with light skin, he or she was placed with a white family to be raised. Enslaved blacks and impoverished whites were used to develop the economy and had no voice in the placement of their children at birth. Names were changed, and diverse breast-feeding was a means to survive.

Archer, Florida, Is My Hometown

Same Standards Emphasized in Every Black Family's Household

Archer, Florida, borders highway twenty-four—
A good place to raise a family—need I say more?
High standards endorsed—common sense in place—
Golden rules established at each home base.

Working parents imparted high expectations—
Children were involved in church–school relations.
Teaming was essential—strong parenting was evident—
Shared rules extended throughout each settlement.

At church and school we set realistic goals—
Teaching children to respect the young and old.
Agreed controlled routines to improve lives
Keep on keeping on—changes were on the rise—

Love without hesitation—our children belonged to us—
If one child was at risk, then it became a must!
I must, you must, and all of us must realize—
A crash in communication—would disrupt our lives.

From every aspect—children were our points of light—
Each one deserved the best of what was right.
Layered with respect from an Archer caring team—
Embracing and encouraging tailored their self-esteem.

Strong neighborhood networks kept us in touch—
Practicing church and school prayer we advanced much.
Those are the good ole days that I so much miss—
When I rewind my internal clock and quietly reminisce.

An Archer Tribute: Poetic Justice
Composed by Rev. Charlie Louis and Lizzie Polly Sams Brown, 1926
Translated by Theresa Marie Brown Robinson, July 30, 1992
Published by Lizzie Polly Robinson Brown Jenkins, June 5, 1995

IN LOVING MEMORY OF OUR ANCESTORS ONCE ENSLAVED

Surname	Given Name	Birth Date	Death Date	Comments
Rollins	Thomas Sr.	1818	1886	Field Laborer
Sams	Richard	1825	1914	Field Laborer
Sams	Juliann	1826	1926	Free Labor
King	Eloise	1836	1936	Free Labor
Dancey	S. D.	1836	1911	Field Laborer
McIntyre	Henry	1844	?	Field Laborer
Peterson	Sir	1845	1928	Field Laborer
Rollins	Martha Ann	1845	1934	Free Labor
McIntyre	Mary	1847	?	Free Labor
Days	Adam C.	1847	1925	Field Laborer
Woodard	Ida	1848	?	Free Labor
Wilkison	C. J.	1848	1917	Field Laborer
Haines	Amos	1848	1905	Field Laborer
James	Eliza	1849	1897	Free Labor
Whitfield	J. B.	1851	1925	Field Laborer
Rollins	Aaron	1851	1935	Field Laborer
Moton	C. T.	1856	1920	Field Laborer
Spikes	Abraham	1857	?	Field Laborer
Ralls	Jancie	1858	1912	Free Labor
Thomas	Julia	1860	1914	Free Labor
Days	Ellen	1861	1925	Free Labor
Latson	John H.	1861	1924	Field Laborer
McKinney	Elbery	1861	?	Field Laborer
Kyler	Frank Sr.	1862	1930	Field Laborer
McIntyre	Abner	1862	?	Field Laborer
Kyler	F. C.	1864	1917	Free Labor
McIntyre	Lucy	1864	1944	Free Labor

ACROSS AMERICA, PEOPLE ARE DISCOVERING
SOMETHING WONDERFUL. *THEIR HERITAGE.*

Arcadia Publishing is the leading local history publisher in the United States. With more than 3,000 titles in print and hundreds of new titles released every year, Arcadia has extensive specialized experience chronicling the history of communities and celebrating America's hidden stories, bringing to life the people, places, and events from the past. To discover the history of other communities across the nation, please visit:

www.arcadiapublishing.com

Customized search tools allow you to find regional history books about the town where you grew up, the cities where your friends and family live, the town where your parents met, or even that retirement spot you've been dreaming about.